MUSEUM OF CAPITALISM

STATEMENT FOR A MUSEUM OF _____

The mission of the Museum of _____ is to educate this generation and future generations about the ideology, history, and legacy of _____.

The Museum strives to broaden public understanding of _____ through multifaceted programs: exhibitions; research and publication; collecting and preserving material evidence, art, and artifacts related to _____; commemorations, reenactments, and other events; distribution of education materials and teacher resources; and a variety of public programming designed to enhance understanding of _____ and related issues, including those of contemporary significance.

The Museum's exhibits are assembled and organized by a multidisciplinary team of curators, artists, writers, historians, and designers. They include provocative photographs, moving images, text panels, installations, and objects illustrating the events and human stories that are part of the epic saga known as _____. Highlights from the displays include rare items from the Museum's own comprehensive archive as well as material obtained by the organizers from significant collections, both public and private. The Museum also manages the distributed collection, warehousing, and periodic display of artifacts of the _____ system owned or created by partners around the world. Much of the evidence of _____ is either eroding over time or simply not known or easily accessible to the public. Our ambition is to connect and integrate these many efforts before the evidence is erased forever.

Our educational work is crucial for establishing justice for the victims of _____ and preventing its resurgence. Notably, the museum will also bring to light the vast number of individuals and communities around the globe who resisted _____ and helped to develop alternatives to it, serving as an inspiration to future generations.

The Museum of _____ was created for the display and interpretation of objects and historic documents. It stands as an authoritative narrative relating to this historical phenomenon. It is, however, in no way intended by the organizers to be a filter for contemporary political issues.

SOURCES: Museum of Communism (Prague) mission statement, Museum of Communism (United States) mission statement, Museum of Apartheid (Johannesburg) mission statement, United State Holocaust Memorial Museum (Washington DC) mission statement

MUSEUM OF (THE MUSEUM OF) CAPITALISM

GRAMMAR OF SELECTED DEFINITIONS OF CAPITALISM

capitalism

(Category) Also _____ (or _____)

a _____

in/under which _____ /

based on _____

(and _____) /

characterized by _____

(and _____).

Compare / cf. / See also _____ (and _____).

SOURCE: various dictionaries

MUSEUM (OF CAPITALISM) OF (THE MUSEUM OF) CAPITALISM

SENSES OF "OF"

1 expressing the relationship between a part and a whole: *a piece of cake |
 a lot of money | a museum of capitalism.*

2 expressing the relationship between a scale or measure and a value:
 an increase of five percent | a height of ten feet | a museum of capitalism.

3 indicating an association between two entities, typically one of belonging:
 the son of a friend | the government of India | a museum of capitalism |
 [with a possessive]: *a museum of capitalism's.*

 - expressing the relationship between an author, artist, or composer and their
 works collectively: *the plays of Shakespeare | the paintings of Rembrandt |
 the museums of Capitalism.*

4 expressing the relationship between a direction and a point of reference:
 north of Chicago | on the left of the picture | museumward of capitalism.

5 expressing the relationship between a general category and the thing being
 specified which belongs to such a category: *the city of Prague | the idea of
 a just society | the museum of capitalism.*

 - governed by a noun expressing the fact that a category is vague: *this type
 of book | the general kind of answer that would satisfy me | the varieties
 of capitalism.*

6 indicating the relationship between a verb and an indirect object.

 - with a verb expressing a mental state: *they must be persuaded of the
 severity of the problem | I don't know of anything that would be suitable |
 I remain skeptical of this museum.*

 - expressing a cause: *he died of cancer | the world was musealized of
 capitalism.*

7 indicating the material or substance constituting something: *the house was
 built of bricks | walls of stone | a museum of capitalism.*

SOURCE: New Oxford American Dictionary. 3rd ed., s.v. "of."

(MUSEUM OF THE) MUSEUM (OF CAPITALISM) OF (THE MUSEUM OF) CAPITALISM

MUSEUM OF A MUSEUM

When we announced the opening of a Museum of Capitalism, we heard four common responses, coming from our partners, collaborators, and other interlocutors—and sometimes our own inner voices. Each closely related to the other, they seemed to be simultaneously objections and agreements.

"But isn't capitalism already a museum of itself?"

We agreed. So we considered calling it Museum of (the Museum of) Capitalism.

"But wait," said someone else: "Aren't all museums museums of capitalism?"

Then perhaps we should call it Museum (of Capitalism) of (the Museum of) Capitalism.

Someone else chimed in: "Aren't all museums, in a way, museums of themselves?"

Then we shall call it (Museum of the) Museum (of Capitalism) of (the Museum of) Capitalism.

Yet another offered this advice: "Isn't a museum of capitalism inherently a project of capitalism?"

Then maybe the full name should be: (Museum of the) Museum (of Capitalism) of (the Museum of) Capitalism (of Capitalism).

That's all well and good, someone said. But you cannot apply these objections in some arbitrary succession. They are not ranked or prioritized; all are equally valid independently of the application of the others. You must consider them all at once, holding each in your mind whenever the name is to be uttered.

Heeding this advice, we arrived at the following: (Museum of the) Museum (of Capitalism [of Capitalism]) of (the [Museum of the] Museum [of Capitalism (of Capitalism)] of) Capitalism (of Capitalism). Which, since this already looks rather mathematical, might be expressed in abbreviations thusly: (M of the) M (of C [of C]) of (the [M of the] M [of C (of C)] of) C (of C).

Here someone interjected: "But we have still retained the structure of the original name by applying each objection only to the original terms and not to the terms of the objections themselves! Is not a 'museum of a museum' also a 'museum of a museum of a museum,' and so on? How can we represent this recursive process?"

And surely, in this process, the placement of parentheses and brackets is of utmost importance. We must choose carefully the terms to which any one operation is applied, just as we select and define any object of study. One misplaced parenthesis can throw off the entire equation.

But perhaps also, as in mathematics, this is an expression whose parts can be canceled out or combined into more succinct expressions. Perhaps what we are doing here is factoring out the divisions of a multiplicative whole, or attempting the same for something not evenly divisible, and the original formula might already contain these objections, these infinitely embedded enunciations, in one simple string.

And perhaps also what we're doing here is not math.

We decided, in the end, to keep the name "Museum of Capitalism."

(MUSEUM OF THE) MUSEUM (OF CAPITALISM) OF (THE MUSEUM OF) CAPITALISM (OF CAPITALISM)

MUSEUM
OF
CAPITALISM

EDITED BY FICTILIS

INVENTORY PRESS

MUSEUM OF CAPITALISM

INTRODUCTION

The Museum of Capitalism began at a time when many people believed capitalism would go on forever. Despite growing evidence of its limits, many were still heavily invested in it. As ever, capitalism's great promise could often outshine its harsh realities. A sometimes compelling case was still made for limited reforms or even expansion or intensification of capitalism to address its shortcomings. Some claimed it had become easier to imagine the end of the world than the end of capitalism. Certainly art excelled at representing and envisioning collapse and ruin. We dreamed of so many alternate worlds, but rarely of alternate economies. But as compounding social and environmental consequences seemed to lead toward inevitable catastrophe, it was capitalism itself which was felt to be inevitable.

In this climate, mere mention of the "C-word" could shut off dialogue or tarnish reputations. It was a sign of ideology at work, as if some unwritten law had been broken, or some secret was being carefully guarded. But there were plenty of good reasons to avoid the term. Historians as well as economists and even activists of many persuasions rightfully questioned capitalism's usefulness as a concept, citing its lack of specificity or its totalizing logic, preferring less controversial or more well-defined terms, or a plurality of various geographically and historically specific "capitalisms." But history has a way of forcing the issue, and putting certain terms—and uncertain ones—back into circulation.

Younger generations coming of age in less stable conditions than previous generations expressed less favorable views toward capitalism, especially after Cold War communism receded from view, replaced with the precarity and austerity of a post-crisis condition that somehow always seemed to be simultaneously pre-crisis. Despite the rigorous work of some historians and economists, often called "radical" or "heterodox" by their mainstream counterparts, research also showed a pervasive lack of understanding of what capitalism was. If we were going to talk about it, we needed to make sure we were talking about the same thing. What had gone so long without saying had become what most urgently needed to be said.

But we didn't just need to *agree on terms*; we needed to *come to terms* with capitalism. To accept the parts of it that we couldn't, for lack of the space and the distance from it. Museums seem capable of providing some of that space and distance. Yet museums have been, and still remain, a no less fraught phenomenon. For a project as oriented towards the future as the Museum of Capitalism, its use of the form of a museum may be puzzling. Museums are still often seen as inherently backward-looking, if not backwards in themselves, a form belonging to the past that prevents us from progressing beyond it. But museums, and the various disciplines that contribute to them, have also been instrumental in shaping our very concept of progress, and our sense of self in relation to society and to the histories we collectively trace. What better form than a museum to call progress into question, and how better to reorient ourselves in the present than with an institution we already use to orient ourselves toward the past?

Indeed, if a visit to the Museum of Capitalism can teach us anything, it's that what is future and what is past, and what in the present can be used to recover the possibilities in both, is not so easy to discern. Prediction, as the forecasters of the future tell us, is about seeing the present for what it is. Museums, like the scientists and artists who make them, can help us do something similar.

The brave artists, scholars, and other collaborators who were willing to join us in creating an institution from scratch have had to feel their way forward with us. And many of the writers included in this volume have stepped outside of their usual comfort zone and tried something different. Everyone involved has had to trust that the pieces would fit together in the end, and that the whole would be greater than the sum of its parts. For their trust, and their work, we are grateful.

The Museum of Capitalism was extremely honored to receive the Emily Hall Tremaine Exhibition Award to open its first major exhibition in Oakland. The award is intended to support challenging thematic exhibitions, and to give curators the time and resources needed to fully explore a concept. The award has seldom been granted to institutions in such a speculative stage as ours, and we are grateful for the Emily Hall Tremaine Foundation's bravery, their trust in our vision, and their support through a difficult political climate in the United States.

Our gratitude also goes out to the Jack London Improvement District, and Executive Director Savlan Hauser, for their partnership and collaboration in realizing the first physical exhibition in Oakland, California. Savlan's tireless work in support of the museum, and willingness to explore complicated partnerships and to engage in difficult conversations about gentrification, placemaking, and the role of the arts in urban development, have renewed our faith in the possibilities of public dialogue and repurposing the built environment of capitalism.

Some have argued that the events the Museum highlights are too recent in memory to be displayed in such a way, that the topic is too sensitive for those who still feel its effects. Others argue that it's too late, that reflection upon the logics and limits of capitalism should have happened long ago, and might have prevented many of the tragedies we have seen play out in recent decades. We maintain that there is no better time than now to make a Museum of Capitalism, to create a place between these perspectives, while clearing a path forward towards our common future. If we wait for the "right" time to act, or pine for some time when we might have done so, we will miss the opportunities we still have to honor the stories of those impacted by capitalism, and to affect the lives of those who will feel its impacts far into the future.

After all, historical tragedies live on. They live on in the minds of survivors and the memories of whole communities. In the bodies of victims and in the bodies of their children. In the minds and bodies of the next group, the next country, the next race, religion, class, gender, or species to inherit the mantle of the excluded, or the exploited, or the extinguished. In the landscape of dust and debris we inhabit, and which inhabits us in turn—our visions, views of the present and dreams of the future, all arranged with the relics and remains of what was. In the new forms historical tragedies take, which insidiously continue the legacies of those preceding them. In remote corners of the world where the lofty resolutions of history do not penetrate, in the holdouts and the holdovers. And in remote regions of the psyche where deep wounds are still felt, and long grudges still held. In so many ways, historical tragedies live on, like the human generations that bear witness to them.

In this way, maybe tragedies aren't historical at all. The past keeps on

happening. Maybe there are no histor-
ical tragedies. Maybe what's tragic
is history itself. The fact that it keeps
repeating, and we have to keep record-
ing it. George Santayana warned
that those who don't remember the
past are condemned to repeat it.
But maybe those who remember the
past are condemned in our own
way, condemned merely to repeat it
knowingly, or to be bound in our
aspirations by its limits, or convinced
by our own learning that we're not
repeating it. There is no "too soon"
and no "too late." Our collective past,
like our personal memories, keeps
changing as we grow. There is only now,
and what we're doing and what we're
not doing with what we have.

Early in the process of creating
this museum, an advisor suggested we
approach the topic of alternative
economics from "a more non-naive
position." It was a delicate way of
pointing out our ignorance. But a few
years into the project, we remain
in so many positions of naivety, as the
expansiveness of the topic tests the lim-
its of our time and energy. No amount
of reading will fully prepare us for
the kinds of futures being anticipated
within this Museum of Capitalism.
We remain in defense of the right to
begin from positions of relative igno-
rance, to stumble forward without
necessarily investigating every path
that has been cleared before us. Action
is sometimes needed, and sometimes
action means creating spaces for more
thought and reflection. Many may
find offense in the errors, omissions,
and inconsistencies we have committed
in these pages, as we have inevitably
also done in the larger programming of
the Museum of Capitalism. We can
only hope these offenses become oppor-
tunities for more thought, more action,
and broader and deeper conversation.

IT HAS BECOME EASIER TO IMAGINE THE END OF THE WORLD THAN THE END OF CAPITALISM.

FREDRIC JAMESON

Annie Wong, Museum of Capitalism architecture competition submission.

model of factory in a case that pumps out smoke

Blake Fall-Conroy, model factory that pollutes its own exhibition space.

IF SOMETHING CAN'T GO ON FOREVER, IT WON'T.

HERB STEIN, ECONOMIST AND ADVISOR TO US PRESIDENTS NIXON AND FORD

HERO OF CAPITALISM

JOHN MAYNARD KEYNES
1883 – 1946
BRITISH ECONOMIST

" The importance of money flows from it being a link between the present and the future."

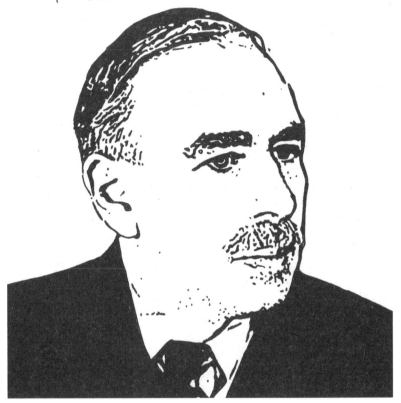

Riiko Sakkinen, *Heroes of Capitalism* series, 2016.

Photographs from the 1967 opening of the Petroleum Hall at the Museum of History and Technology, Washington DC, now known as the National Museum of American History.

WHEN YOU CUT INTO THE PRESENT, THE FUTURE LEAKS OUT.

WILLIAM S. BURROUGHS

Untitled mousetrap design from early twentieth-century US catalog.

HISTORY PRODUCES NOT ONLY THE FORCES OF DOMINATION BUT ALSO THE FORCES OF RESISTANCE... THE PAST IS LARGER THAN THE PRESENT, AND IS THE EVER-GROWING AND ONGOING POSSIBILITY OF RESISTANCE TO THE PRESENT'S IMPOSED VALUES, THE POSSIBILITY OF FUTURES UNLIKE THE PRESENT, FUTURES THAT RESIST AND TRANSFORM WHAT DOMINATES THE PRESENT.

ELIZABETH GROSZ

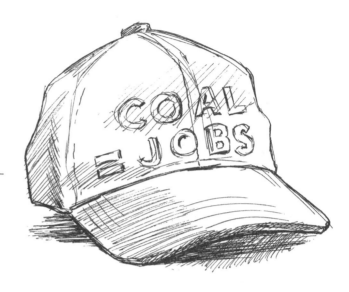

Maker unknown, COAL = JOBS hat, 2008 (artist's rendering).

This headwear, often worn as everyday casual dress, was known as a "baseball cap" because it was part of the traditional uniform worn by players in the sport of baseball, with a brim pointing forward to shield the player's eyes from the sun.

An "ASI number" printed on the tag of the hat indicates its manufacturer was registered with the Advertising Specialty Institute, a business that was focused on organizing and classifying suppliers' products in catalogs, allowing for easy reference by promotional product distributors and salespersons. In a culture awash with images, and habits of consumption tied to individual, personalized "lifestyle" choices, a political cause such as this became yet another brand to be promoted through the consuming of merchandise, an opportunity for wearers to express their identities through the act of consumption. While most baseball caps bore the names of logos of sports teams, the use of a political slogan on this hat suggests the ways politics itself, especially in the American two-party system, was a kind of sport, with supporters of each "side" of a contest rooting for their team to win.

In this case, the political lobby on display is the American Coalition for Clean Coal Electricity ("ACCCE"), an industry group that sought to rebrand coal as a clean energy source, spending over $35 million in 2008 to mount a major public relations campaign designed to promote public awareness of clean coal in the context of the Presidential race. They flooded the election season with national and local ad campaigns, which included the production of these hats. Paid agents distributed the hats for free at political rallies so that their wearers could be seen in media coverage, giving the appearance of a grassroots-based citizen movement for a campaign primarily created, conceived, and funded by public relations firms, corporations, and industry trade associations.

TOO SOON?

FICTILIS

After September 11th, 2001, and the near-instantaneous media saturation of local tragedies in the United States in the decades that followed, cautionary appeals for the postponement of comedy (sometimes in the form of premature announcements of the "death of irony") became familiar. So too did mocking imitations of that very sentiment— with their own instantaneity. It was perhaps because the earnest appeals had a formulaic quality to them that the mockery of them was so swift, and yet the mockery also became formulaic, as mockery so often is. Both the cautionary and the mocking sentiments crystallized into a singular expression—"too soon." It was often difficult to tease apart the earnest from the ironic in this expression, and in this sense, it captured what was an utterly contemporary relation to history.

The phrase had its own prehistory in the second half of the twentieth century, as the United States was learning to consume tragedies as mass media spectacles. Popular *Tonight Show* host Johnny Carson used it as part of a running gag that started with an unpopular joke referring to the assassination of Abraham Lincoln. When the audience fell silent, or mustered only tepid laughter, Carson remarked to his sidekick Ed McMahon, "it's too soon." After each subsequent attempted but unsuccessful Lincoln joke, the expression "see, it's too soon" effectively became the punchline, adding a level of detachment that somehow redeemed it. Although

the historical tragedy of Lincoln's assassination was over 100 years old, it remained sensitive to American audiences, though not so sensitive that the tragedy couldn't be instantly spun back into comedy by a seasoned professional like Carson. In the meta-joke about a joke, the original joke is no longer a joke, but a retelling of the tragedy which is instrumentalized as part of the routine.

The expression became a kind of shorthand among comedians to refer to jokes about sensitive events, until it entered into popular usage following the accelerated cycles of tragedy and media coverage of the early twenty-first century. The authority on early twenty-first century slang UrbanDictionary.com has an entry tagged "#controversial #unbelievable #inbadtaste #not cool," in which a user named Attomar posts a definition for "too soon":

A phrase used to respond to someone making a comment that was intended to be funny, but touches on subject matter that shouldn't be joked about, usually because it was a recent event.

Attomar's usage example references the recent death of Australian wildlife expert Steve Irwin, aka "The Crocodile Hunter," who was pierced in the chest by a stingray barb while filming an underwater documentary.

person1: Ah man, i didn't study for the final. I'm gonna fail for sure.

person2: Dude, you're screwed like Steve Irwin in a tank of stingrays.

person1: Too soon.

The definition refers to things that "shouldn't be joked about." And yet, as the usage example suggests, this phrase is usually said sarcastically, in a joking manner.[1] That is, the very injunction against joking is presented as a joke: I'm joking that you shouldn't be joking. The speaker doesn't really believe that it is too soon. If they did, they wouldn't make the joke.

The force of the joke comes from a kind of performance of historical tragedy, from "playing the victim." In this exaggerated performance, the joker is affirming their own distance from the tragedy itself, from feelings of its severity and from their status as victims or as persons in some kind of empathy or solidarity with actual victims. Or as the kind of person who would ever voice such a concern in earnest, about the event in question or by extension any other. And the person being mocked is not the person who is accused of saying something "too soon," but the person who would take such an accusation seriously, that is, the victims of tragedy and those who would take the victims seriously.

We are already adept at this. We perform historical tragedy when we do not identify as its victims. Trying on the role of victim, we reveal the naked desperation of our irony and our aloofness, our actual distance from historical agency.

Joking is about testing the personal limits of what we care about and what we don't, in reaction to oppressive conditions. It can also be about changing those limits, or enduring, if not changing, those conditions. Among the things we should "never forget" is that, for prisoners in German concentration camps during the Holocaust, joking was, as one survivor put it, "what kept us alive."[2]

And yet, joking has a strange relation to history, and the element of time complicates things. It was the first host of the *Tonight Show*, Steve Allen, who first uttered the formula, "comedy is tragedy plus time." Psychologists studying the problem of when tragedies become appropriate subject matter for humor have noted that distance in space also makes a difference, so that a tragedy might be said to have a kind of epicenter, radiating out from which humor becomes more and more acceptable. But feelings of the severity of tragedy can overcome even the longest distances in space or in time.

Joking aside, more serious debates about the appropriate timing of actions coming after tragedies tend to cluster around the act of memorializing. Memorializing being a kind of reliving of tragedy that is supposed to bear no traces of joking. And yet, the resemblance is uncanny, and the same dynamics are at play: the detachment, the performance, the thin line between comedy and tragedy. Whether we see things one way or another depends on where we see ourselves across that line in space, or along that timeline. And maybe the most comic thing, or the most tragic thing, and the reason it's so difficult to tell the difference, is that both—as Marx reminds us—may just be history repeating itself.

1 This example has yet another layer of irony if we assume Steve Irwin's death is of little significance to person1 and person2. This is probably also the case for their creator Attomar, who like many UrbanDictionary.com users is encouraged to post examples that are amusing and therefore up-voted by other users.

2 See Dr. Chaya Ostrower's study of the use of humor in the Holocaust: Chaya Ostrower, *It Kept Us Alive: Humor in the Holocaust* (Jerusalem: Yad Vashem Publications, 2014).

GENRES OF CAPITALISM AND THE FOUR SCIENCES OF SOCIAL HISTORY

STEPHEN SQUIBB

We commemorate the institution of a museum of capitalism as the first step in ending a long and painful process. When capitalism became the object of a museum, it became history and we all got a bit safer and healthier, regardless of the affective register attached to the term. Nothing was more important to our collective survival than more—and more scientific—approaches to capitalism. Even in 2017, we liked to keep our science and our history separate—a mandate the Museum of Capitalism refused. As an institution dedicated to the science of history, the Museum of Capitalism is both a history and a science museum. For it was only by approaching history scientifically that capitalism was apprehended.

Similar to the way in which alchemy once contained chemistry and astrology once contained astronomy, capitalism contained four distinct research programs, organized around four distinct social-historical phenomena. When we encountered the term "capitalism" it usually referred, consciously or otherwise, to one of these four genres, often in combination. Each genre included both pro- and anti-capitalist varieties.

The four social-historical objects that capitalism referred to are production, reproduction, representation and distribution. Each of these can replace capitalism as the answer to questions like: Where do our identities come from? What does social history consist of? How are divisions like those between politics and economics, nature and culture, the material and the immaterial instituted in the first place? Reproduction, representation, production, and distribution are *transhistorical materialities* because they persist across time and space as the conditions of possibility for the articulation of questions like these. It is important to examine each one separately, if only to recognize how capitalism encouraged us to overlook their differences, mix them up, or to metaphysically elevate one above another.

PRODUCTION
Production refers to the transhistorical materiality of the labor-process. To describe capitalism—or any other –ism—as a mode of production is to describe it as one of many possible ways of organizing the synthesis of goods.

How is labor-power mixed with tools and resources to produce useful objects? Since capital is a circuit or pattern of accumulation, capitalism as a mode of production would mean organizing the synthesis of goods around accumulation, in order to maximize a surplus denominated in whatever way. Pro-capitalist productionists claim that organizing production for accumulation is the best of all possible kinds of productive organization, and they seek to minimize any intervention in the labor-process that might disrupt or dilute accumulation. Anti-capitalist productionists argue that organizing production entirely in the service of accumulation is destabilizing or damaging, and they seek to reorganize the labor process to create more sustainable infrastructures in the long term.

The hallmark of productionism, be it pro- or anti-capitalist, is the discourse of *work*. Are we working too much or too little? Is work liberating or oppressive? Are workers all-powerful heroes, pathetic victims, dissembling criminals, or the future of us all? Is the goal of an autonomous society less work or better work? All of these questions take place within productionism—as do efforts to reframe other approaches to capitalism in these terms, a gesture which is itself frequently indicative of a productionist approach.

REPRESENTATION

Representation refers to the transhistorical materiality of the value-process. Capitalism is not often described explicitly as a "mode of representation," but it is often thought of that way. Many pro-capitalists, for example, are representationalists who argue that because of the price signal or similar representational mechanisms, capitalism is more accurate than other, competing modes of representation. Anti-capitalist representationalists make the opposite claim, namely that capitalism refers to the proliferation of bad, inaccurate or otherwise maleficent representations,

due to processes like commodity fetishism or the spectacle. In both cases what is at issue is the relative accuracy of the representation of value: do our signifiers of value correspond to what is signified by that term? Does this or that set of institutions—whether we describe these as capitalist or otherwise—aggravate this distance or ameliorate it?

The hallmark of representationalism is the discourse of *presence*. Is value present where we say it is? Or is it someplace else? Presence is what links the concept of value to the concept of meaning. Considering either meaning or value requires locating its presence or its absence. When is value visible publicly and when is it hidden privately within a hoard?

Often capitalism has been approached by combining elements of both productionism and representationalism, as with the celebrated debates over the marginal and labor theories of value, which concerned whether the labor-process should be considered as an absolute limit to the value-process, or vice versa.

REPRODUCTION

Reproduction refers to the transhistorical materiality of the sex-process. How does a given set of social-historical institutions allocate identities and resources in the process of reproducing itself? Who or what is interpolated in which position within the forces and relations of reproduction? Many twenty-first-century anti-capitalists are reproductionists on account of the overwhelming scientific evidence that the dominant pattern of accumulation will be impossible to reproduce. Pro-capitalist reproductionists would include not only those who argue that organizing reproduction in the service of accumulation is the best method for doing so, but also those who believe that unlimited accumulation is so powerful and inevitable that submitting to its dictates is the only method of reassuring reproduction of whatever sort, however impoverished or miserable.

Considering the materiality of reproduction alongside that of production and representation is thus a good way of highlighting the difficulties in speaking of capitalism as predominantly referring to one or another of these histories. We quickly see, for example, that almost all of what Marx and Engels said about capitalist appropriation of labor in terms of work and production applies even more to the patriarchal appropriation of the results of the labor in terms of parturition—or giving birth—and reproduction. Thinking the sex-process and the labor-process as distinct concepts thus allows us to see where a given instance of one or the other fits both descriptions.

The hallmark of reproductionism is the discourse of *difference*. How much difference is necessary in order to reproduce the desired kind of sameness? How must we change in order to persist as something recognizable to ourselves? In what way will we have to live differently in order for our planet to maintain the same capacity to support life? To what extent is instituting difference advisable or even possible in the process of reproduction? These are reproductionist questions.

DISTRIBUTION

Distribution refers to the transhistorical materiality of the body-process. The body should be understood not only in its fleshly individuality, but also in the sense of the body politic. The borders of both being determined by the distribution of pain. Pro-capitalist distributionists argue that capitalism is preferable to war as a method for distributing pain, and claim that any effort to interfere with distribution for accumulation will lead to the resumption of war and should be avoided. Anti-capitalist distributionists argue that capitalism is already war, and that those receiving an excess of pain should not hesitate to redistribute that pain towards their enemies. Distributionists, whether anti-capitalist or

otherwise, can be recognized by their fondness for military or military-style institutions, organizations, and cultures as these are designed to intervene in the body-process most directly and intensely.

The hallmark of distributionism is the discourse of *violence*. Does capitalism signify an increase in violence or its mitigation? What sorts of transactions or exchanges can be considered violent under which circumstances? Even strategies and tactics of nonviolence, whose historical success cannot be wished away, take place within distributionism insofar as these intervene in the unfolding of the body politic.

THE FOUR SCIENCES SIDE BY SIDE

The enumeration of four distinct sources for much of what was formerly understood as capitalism was not intended to separate them permanently, any more than the existence of something called biology and something called chemistry inhibits the study of biochemistry. On the contrary, the advantage of thinking about reproduction, distribution, representation and production as the four sciences of social history is that it helps us grasp in greater detail *what it is we talked about when we talked about capitalism*.

The pursuit of such clarity has made the Museum of Capitalism a living monument and an institution worthy of all those lives given, taken, spent, or saved in the unfolding abolition of our collective cruelty to one another.

CAPITALOCENTRISM AND ITS DISCONTENTS

J. K. GIBSON-GRAHAM

Capitalocentrism was a mode of thinking that came to dominate academic and policy discourse in the late twentieth century. It was a semi-unconscious framing that normalized capitalist economic relations, instating them as the only legitimate way of securing livelihoods. Capitalist corporations, free markets for commodities and finance, waged and salaried labor, and private property relations were promoted as the most efficient mechanisms for ensuring societal well-being. "Capitalist" economies were seen by business owners, investors, politicians, government officials, the shareholding public, and academic economists—that is, the beneficiaries and supporters of capitalist accumulation—to be at the pinnacle of economic development.

Within this capitalocentric knowledge frame, other forms of business enterprise, of relations to property, of transactions of goods, services, finance, and labor were only ever identified with respect to capitalist practices. They were positioned as the opposite of capitalism, subordinate and or a complement to capitalism or contained *within* capitalism. Their identities were seen as precarious, always under pressure to change, to *become* capitalist.

So it was that economic practices, such as subsistence small family farming that supported millions of people around the world, or cooperative enterprise that shared wealth between member cooperators, or reciprocal labor exchanges that supported community livelihoods, or unremunerated caring labor performed in homes and social institutions, were represented as inefficient, backward, primitive, lagging, and incapable of innovation.

Capitalocentrism followed on from phallogocentrism, another prominent way of reasoning at that time. Both were binary ways of thinking that divided the world and identified and privileged "master" terms. Under the influence of phallogocentrism the image of "woman" could not establish an independent and valued identity that was not negatively tethered to a more fulsome and positively valued image of "man." Likewise within a capitalocentric knowledge system, economic activity that was not capitalist was portrayed as incapable of standing alone, of having the dynamism to respond to needs or innovating in the face of challenges—qualities putatively attributed to capitalism.

What is intriguing is that even critics of capitalism, such as those who railed against exploitation and imperialism, embraced a capitalocentric worldview. Here it was the powerful representation of capitalism as a system that dominated analysis, such that every critical revelation or exposure of violence served to strengthen

capitalism's discursive dominance. Capitalocentrism morphed into a mantra, an organizing narrative that obstructed thinking and dulled the senses of intellectual and political discernment.

Eventually a certain kind of paranoia took over. Every change was seen as a symptom of capitalism's flexibility; every challenge was inevitably co-optable to capitalism's design. The fall of Soviet socialism and the opening of Chinese communism to state capitalism were fuel to this furious refusal to think difference and possibility. The emergence of more equitable ways of distributing wealth and supporting livelihoods within social democratic nation states provided, for some, a glimmer of a kind of "tamed" capitalism. But, rather than reading the ongoing challenges faced by social democracy as problems to be solved, any change was read as weakness and an inability to stand up to the colonizing forces of capitalism.

Capitalocentrism prompted all kinds of conflation—the desire for individuality was fused with the universal appeal of capitalist consumerism, the inexperience and reticence around participation in collective economic decision-making with the ascendency of self-interest, the concern to acquire meager amounts of cash to make ends meet with the embrace of capitalist entrepreneurialism, the greedy fraud of immoral hedge fund managers with the natural workings of the capitalist market. There was not much room in this knowledge formation for exploration, for the kind of weak theorizing that opened itself to surprise, to creativity, to the formulation of new languages with which to grasp the evolving world.

When, somewhere in the early part of the twenty-first century, it became clear to the scientific community that anthropogenic climate change was threatening the survival of the human species and the web of life it had come to rely on during the long Holocene summer, capitalocentrism was dealt its final hand. There were those who wanted to name the new geological era the "Capitalocene" to signal the upturn in indicators of global warming that began with the industrial revolution.

By the end of the first quarter of the twenty-first century the near impossibility of thinking outside capitalism had produced bizarre outcomes. At the same time that politicians continued to hoodwink voters into thinking that capitalist growth facilitated by corporate tax cuts and industry deregulation could generate jobs, robots and computer generated algorithms were taking over most of the production, accounting and customer servicing functions that kept capitalist corporations and financial institutions going. In the face of austerity programs that dictated the scaleback of welfare provisions so that capitalism could thrive unfettered by high taxes, citizens experimented with a myriad of livelihood supporting activities to survive. Retrenched workers turned to self-employment in the "black" economy, jobs in the "sharing" economy, barter and reciprocal exchanges of labor and goods. Long-term unemployed people and young job seekers were absorbed into the "social" economy, working in nonprofits and social enterprises. There was a resurgence of interest in worker-owned cooperatives and building supply chain interconnections within a "solidarity" economy of cooperative businesses. In the burgeoning care sector the abuses of private profit making were exposed and new regulations allowed for the emergence of a hybrid model involving supported family and volunteer carers working with care cooperatives and social enterprises. And, despite the seeming ascendancy of climate change scepticism and anti-environmentalism, some leading capitalist firms re-centered their operations on an ethic of care for

the environment, pioneering a form
of commoning that shared bene-
fit to a community beyond private
shareholders.

None of these "alter" economic
activities were assisted or strengthened
by mainstream economic discourse.
Instead, capitalocentric thinking
prevailed, continuing to inform policy
makers' obsession with market deregu-
lation and to facilitate the growth
of obscene inequalities. And yet ... in
the cracks between these less recognized
lived practices and material technolo-
gies, a certain light filtered through.
The self-organizing aspect of markets
began to pick up and amplify emerging
possibilities. The faint stutterings of
a new language of post-capitalist liveli-
hood assemblages started to be heard.

*J. K. Gibson-Graham would like to acknowl-
edge her debt to the fertile thinking of the
Community Economies Collective,
especially to her co-authors of* Take Back
the Economy: An Ethical Guide for
Transforming Our Communities, *Jenny
Cameron and Stephen Healy. Thanks also
to Ethan Miller, Isabelle Stengers, and
Leonard Cohen for evocative phrases and
framings that she has gratefully borrowed.*

Period
16th–18th century

See also
Feudalism
Industrial Capitalism

AKA: Merchant Capitalism, Mercantilism

The theory and system of political economy prevailing in Europe after the decline of feudalism, based on national policies of accumulating bullion, establishing colonies and a merchant marine, and developing industry and mining to attain a favorable balance of trade.
 —American Heritage Dictionary

Period
Late 20th–early 21st century

See also
Philanthrocapitalism

When you buy something, your anti-consumerist duty to do something for others, for the environment, and so on, is already included into it. If you think I'm exaggerating, you have them around the corner, go into any Starbucks Coffee, and you will see how they explicitly tell you, I quote their campaign; "It's not just what you are buying; it's what you are buying into." You see this is what I call cultural capitalism at its purest. You don't just buy a coffee you buy in the very consumerist act, you buy your redemption from being only a consumerist. But the remedies do not cure the disease, they merely prolong it; indeed the remedies are part of the disease … The proper aim is to try and reconstruct society on such a basis that poverty will be impossible.
—Slavoj Zizek, *First As Tragedy, Then As Farce*, 2009

Period
Various periods: Genoese in the 16th century and Dutch in 17th and 18th centuries, pre-WWI Germany, post-WWII United States

See also
Rentier Capitalism
Monopoly Capitalism

AKA: Finance Capitalism, Rentier capitalism

Financial capitalism, or pecuniary capitalism, subordinates the capitalist productive process to the circulation of money and monetary assets, and, hence, to the accumulation of money profits, as such. It presupposes a highly developed banking system, an equity market, and corporate holdings of wealth through share ownership. As Thorstein Veblen pointed out, whole industrial complexes, as well as buildings and land, become the subject of speculative profit and loss.

—William Fielding Ogburn, *A Handbook of Sociology*, 1947

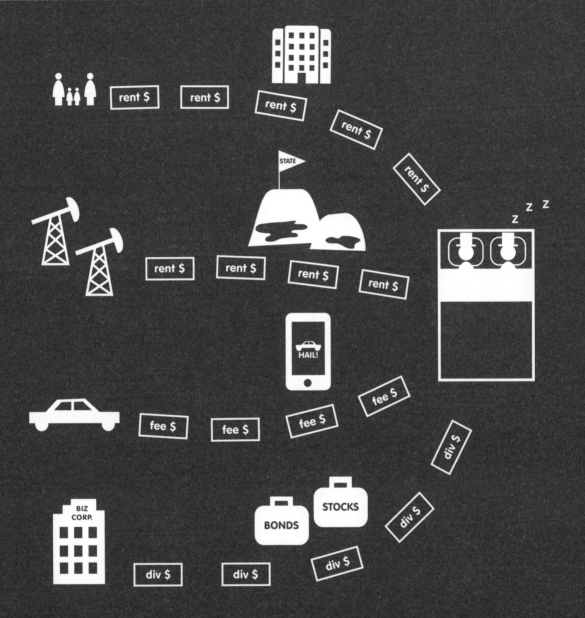

Period
19th–early 21st century

See also
Economic Rent

AKA: Rentier State

We live in the age of rentier capitalism … "Rentiers" derive income from possession of assets that are scarce or artificially made scarce. Most familiar is rental income from land, property, minerals or financial investments, but other sources have grown too. They include the income lenders gain from debt interest; income from ownership of "intellectual property"; capital gains on investments; "above normal" company profits (when a firm has a dominant position); income from subsidies; and income of financial intermediaries derived from third-party transactions.
— Guy Standing, "The Five Lies of Rentier Capitalism," 2016

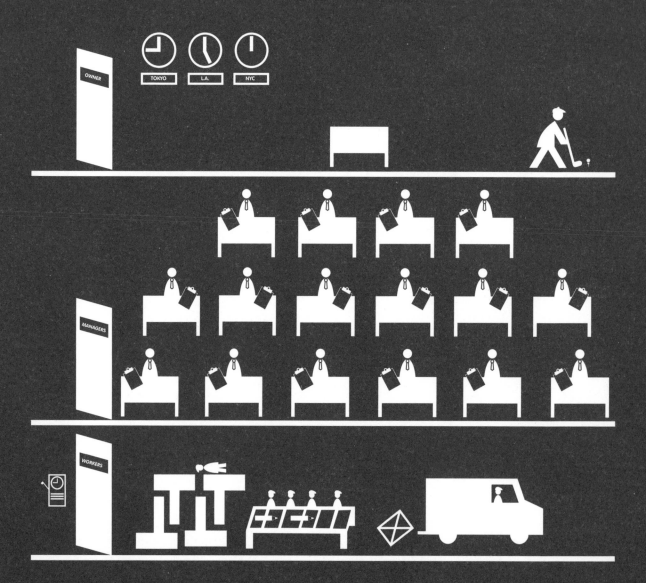

Period
1980s–present

See Also
US Capitalism
Commercial Capitalism
Financial Capitalism
Managerial Capitalism

[Managerial Capitalism] differed from traditional personal capitalism in that basic decisions concerning the production and distribution of goods and services were made by teams, or hierarchies, of salaried managers who had little or no equity ownership in the enterprises they operated. Such managerial hierarchies currently govern the major sectors of market economies in which the means of production are still owned privately, rather than by the state.
—Alfred D. Chandler Jr, *The Emergence of Managerial Capitalism*, 1984

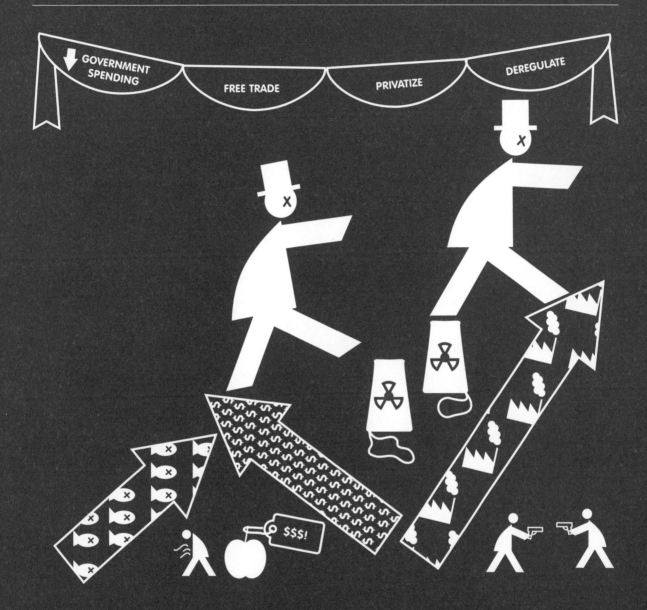

Period
2000s

See also
Zombie Banks
Zombie Neoliberalism

Neoliberalism is dead but it doesn't seem to realize it. Although the project no longer "makes sense," its logic keeps stumbling on, like a zombie in a 1970s splatter movie: ugly, persistent and dangerous. If no new middle ground is able to cohere sufficiently to replace it, this situation could last a while… all the major crises—economic, climate, food, energy—will remain unresolved; stagnation and long-term drift will set in. Such is the "unlife" of a zombie, a body stripped of its goals, unable to adjust itself to the future, unable to make plans. A zombie can only act habitually, continuing to operate even as it decomposes. Isn't this where we find ourselves today, in the world of zombie-liberalism? The body of neoliberalism staggers on, but without direction or teleology.
—*Turbulence* magazine, 2009

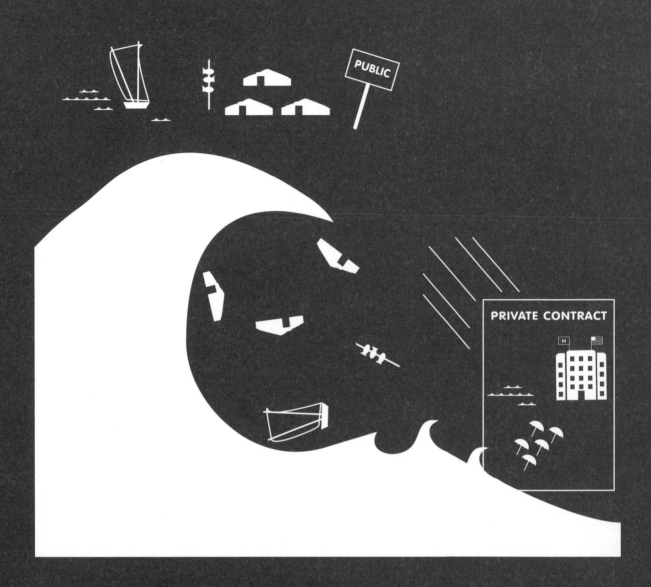

PUBLIC

PRIVATE CONTRACT

Period
**1970s–present, especially post-2003
United States**

The practice (by a government, regime, etc.) of taking advantage of
a major disaster to adopt liberal economic policies that the population
would be less likely to accept under normal circumstances.
 —Dictionary.com

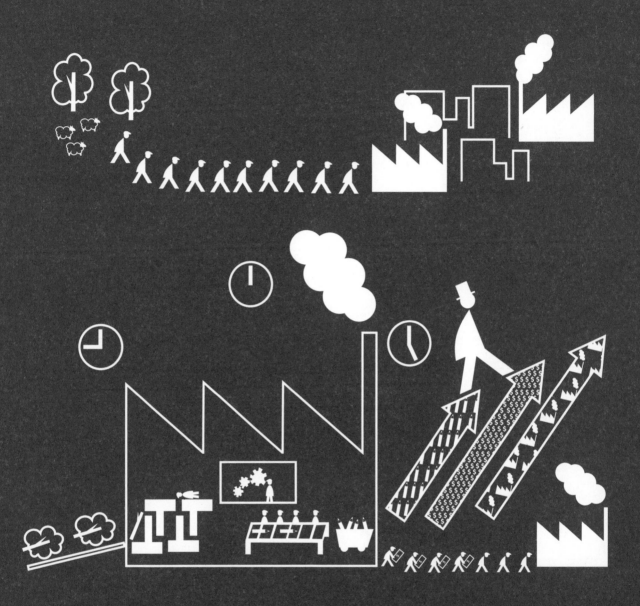

Period
1800s–late 20th century

See also
Post-Industrial Capitalism
Fordist Capitalism
Mercantile Capitalism

Karl Marx began to analyze [industrialization] more systematically, viewing it as a distinct stage in the long evolution of human society. To him, industrial capitalism, based on factory work and wage labor, was preceded by feudalism—a system in which the owners of the large landed estates had established their domination over the mass of dependent peasants. According to Marx, this feudal system suffered increasingly from its inner contradictions and the conflicts it had been generating between the exploitative landlords and the exploited peasants. By the eighteenth century, these contradictions had, in Marx's view, become so serious as to trigger a revolution from which a new socioeconomic system, industrial capitalism, was born. In it, the bourgeois industrial entrepreneur had replaced the feudal lord and exploited proletarianized factory workers through wage labor.
—Thomas Gale, Encyclopedia.com, 2006

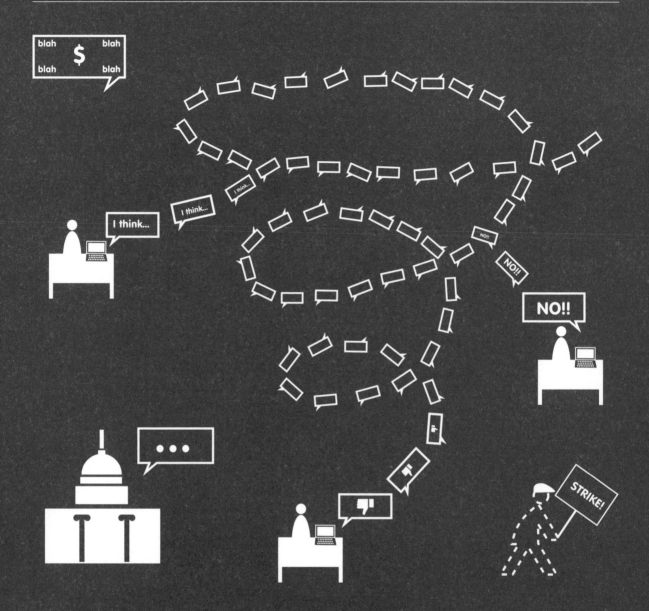

Period
2000s–present

See also
Linguistic Capitalism
Cognitive Capitalism

Communicative capitalism designates that form of late capitalism in which values heralded as central to democracy take material form in networked communications technologies. Ideals of access, inclusion, discussion, and participation come to be realized in and through expansions, intensifications, and interconnections of global telecommunications.
— Jodi Dean, *Communicative Capitalism: Circulation and the Foreclosure of Politics*, 2005

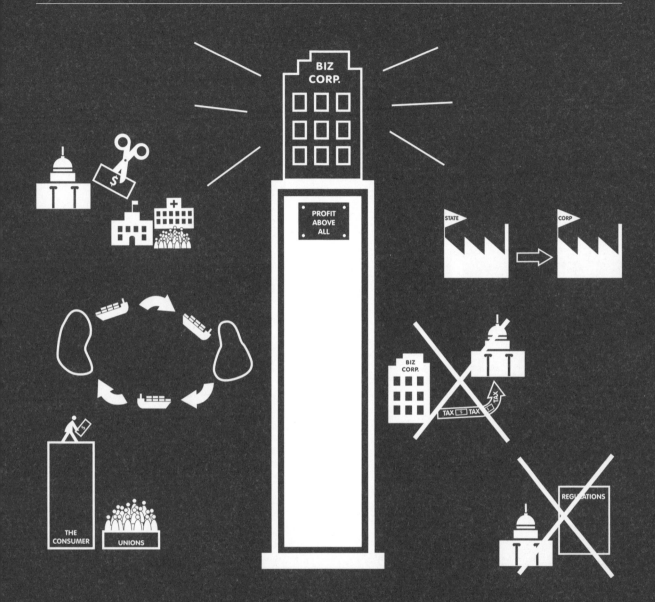

Period
19th and 20th centuries

See Also
Classical Liberalism

AKA: Neo-liberal Capitalism, Neoliberalism

Neoliberalism is a philosophy in which the existence and operation of a market are valued in themselves, separately from any previous relationship with the production of goods and services, and without any attempt to justify them in terms of their effect on the production of goods and services; and where the operation of a market or market-like structure is seen as an ethic in itself, capable of acting as a guide for all human action, and substituting for all previously existing ethical beliefs.
 —Paul Treanor, *Neoliberalism: Origins, Theory, and Definition*, 2005

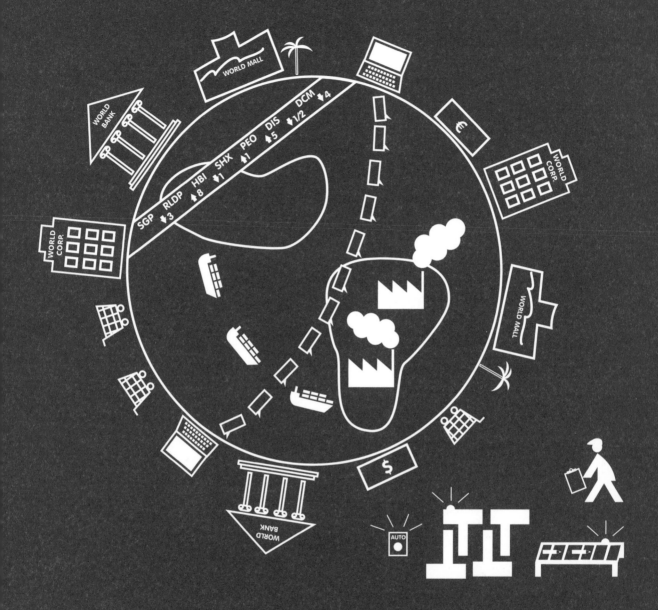

Period
1945–present

See Also
Early capitalism
Neo-capitalism
Latest Capitalism
High Capitalism
Advanced Capitalism

AKA Neo-capitalism, Latest Capitalism, High Capitalism, Advanced Capitalism

What "late" generally conveys is the sense that something has changed, that things are different, that we have gone through a transformation of the life world, which is somehow decisive but incomparable with the older convulsions of modernization and industrialization, less perceptible and dramatic, somehow, but more permanent precisely because more thoroughgoing and all-pervasive.
—Frederic Jameson, *Postmodernism, or the Cultural Logic of Late Capitalism*, 1991

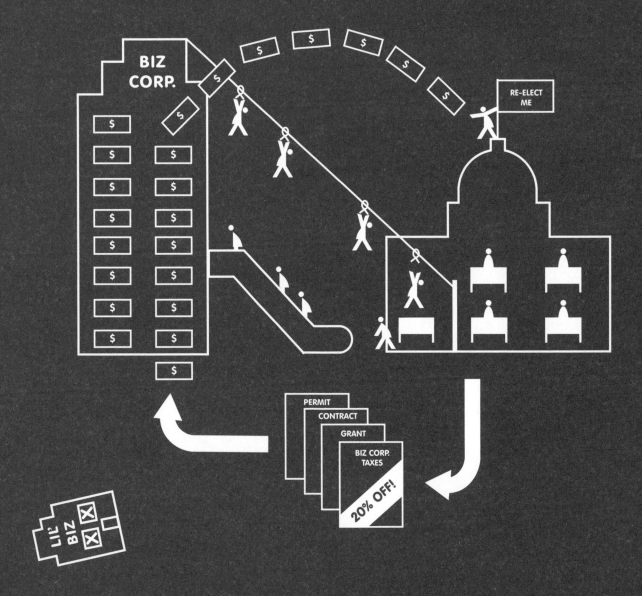

Period
2000–present

See also
Ersatz Capitalism
Lemon Socialism
Skirt Capitalism
State Capitalism

It's crony capitalism. That's capitalism, you do things for your friends, your associates, they do things for you, you try to influence the political system, obviously. You can read about this in Adam Smith. If people read Adam Smith instead of just worshipping him, they could learn a lot about how economies work. So, for example, he's concerned mostly with England, and he pointed out that in England, and I'm virtually quoting, he said the merchants and manufacturers are the principal architects of government policy and they make sure their own interests are well cared for, however grievous the effects on others, including the people of England.
—Noam Chomsky, "Black Faces in Limousines" interview, 2008

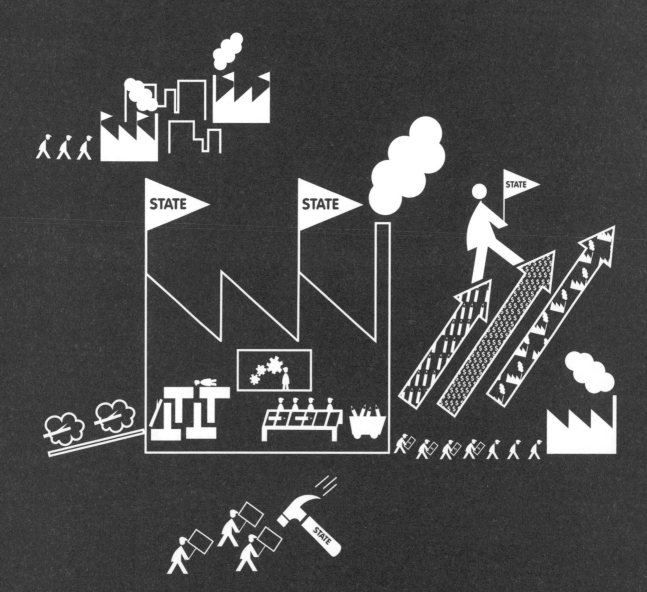

Period
1980s–present, but earlier usage exists

See also
State monopoly capitalism
crony capitalism

AKA: state monopoly capitalism

State capitalism is defined as capitalism in an environment wherein the capitalist enterprise is a component part of the state bureaucracy, and the receivers of capitalist surplus value are state appointed bureaucrats. Many social theorists have classified the Soviet Union and CMEA nations, in general, as state capitalist social formations because most of the GDP in those economies was generated by capitalist enterprises that were within the state bureaucracy, and officials in the state bureaucracy were the appropriators of enterprise surplus value.
—Satya J. Gabriel, *State Capitalism Defined*, 2014

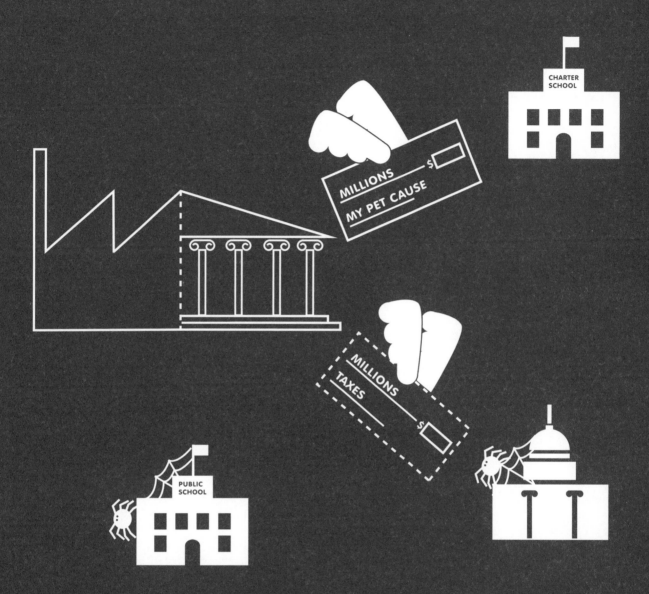

Period
2000s–2010s

See also
Cultural Capitalism
Conscious capitalism

AKA: Philanthropic Capitalism, Philanthro-capitalism

Philanthropic capitalism is the idea that capitalism is, or can be, charitable in and of itself. The claim is that capitalist mechanisms are superior to all others (especially the state) when it comes to not only creating economic but also human progress; that the market and market actors are, or should be, made the prime creators of the good society; that capitalism is not the problem but the solution to all the major problems in the world; that the best thing to do is to extend the market to hitherto private or state processes; and, finally, that there is no conflict between rich and poor, but that the rich is rather the poor's best and possibly only friend.
 —Mikkel Thorup, *It's All Part of Capitalism: How Philanthropy Perpetuates Inequality*, 2015

THE RECENT PAST OF CAPITALIST FUTURE

INGRID BURRINGTON

Scour the back catalogue of corporate YouTube channels and eventually you'll find the future vision concept videos. Companies like Microsoft, Samsung, Shell, and IBM produce these short vignettes of a World of Tomorrow for an unclear audience—they're typically too long to be commercials and mostly document products that don't actually exist yet. They reflect a presumed roadmap of future technology developments, developments that define the company in question as cutting-edge and innovative. Recent editions of these videos tend to include elaborate touchscreen interfaces on devices ranging from flight boarding passes to classroom smartboards to bracelets that pop with social media notifications. They were presumably not filmed in an actual city or a soundstage, but literally within an architectural render of a future city, the kind that seem to emerge out of Dubai every three months. The future is bright, full of gestural and voice interfaces that actually work on the first try, and populated with good-looking earnest young professionals poring over bar charts.

Such cheerful corporate visions of the future are far from new, but in general there's something unsettling about them. Mostly I think it's that they're too clean—no fingerprint smudges on the infinitude of touch screens, no grease or bits of trash inside self-driving cars. When did the future get so ... tidy? The future is an uncertain, ancient, grimy place, and prior to the mid-twentieth century, humanity's encounters with the future involved uncertain, ancient, grimy ritual. For centuries, humans invoked dark arts and gazed into black mirrors and tea leaves, in an effort to glimpse ever-so-slightly ahead of the space-time continuum. The immaculate, rational future of architectural renders and touch screen interfaces is a more recent phenomenon in human history, one in large part perpetuated and cultivated by an industry and discipline that's broadly defined as future studies.

The various job titles of the futures industry are all equally vague to an outsider and tend to mutate according to the needs of industry—strategic forecasting, foresight analysis, futurology, coolhunting, visionaries. People in these disciplines might, without a hint of irony, put the term "thought leader" on their business cards. Across the variants of futurist there is a shared disdain for and effort to distance contemporary futures practices from that long history of divination and more occult futures-seeking. For the futures expert, to draw connections between divination and strategic foresight is akin to asking a molecular chemist for their thoughts on alchemy: cute, but annoying. Modern futurists may lean on the rhetoric of

magic for metaphor and a degree of poetics, but much of the futures industry as a whole owes a greater debt to legerdemain than divination. The modern futurist's work is rational, logical, and quite importantly factual, backed by streams of real-time data and predictive models.

Most histories of the modern corporate futures field locate its origins in the equally vaguely named discipline of "operations research," or as it's known in acronym-loving military speak, OR. Peaking in significance during World War II, OR emerged from US military logistics research that used nascent analog and digital computing technologies to make more informed decisions grounded in computational analysis and statistical modeling. The brightest minds of World War II operations research would go on to leadership roles at the RAND Corporation, a quasi-governmental private think tank created in 1948 to provide research and development support to the US military. At RAND, operations research gave way to two major developments that would become integral to the pursuit of rational futures: game theory and scenario planning. Both were integral to the development of Cold War-era military simulations and war games. Of the two, scenario planning is the one that employs more narrative interpretation, and is generally expected to be attuned to the subtleties of here and now rather than relying only on calculations and archetypes.

While a number of people (actually, mostly men) are associated with the development of Western scenario planning, the figure most associated with its use at RAND was Herman Kahn, a fiercely smart and avuncular public figure who rose to prominence in 1960 when he published *On Thermonuclear War*, a book that worked through various scenarios in which nuclear war could actually take place instead of continuing to insist on deterrence as a strategy for avoiding nuclear holocaust.

He's probably best known for being the source of concepts that Stanley Kubrick would later borrow for his film *Dr. Strangelove*, the "doomsday device" being perhaps the most memorable.

On Thermonuclear War galvanized the public by insisting on thinking through what were, at the time, unthinkable futures (in 1965, Kahn published a book titled *Thinking the Unthinkable* on this very point). Its controversial reception and Kahn's own growing frustrations within RAND led him to leave in 1961 and form the Hudson Institute, a scenarios think tank in New York that today lives on as a conservative policy shop in Washington, DC. With the Hudson Institute, Kahn's scenarios work extended beyond the military applications that he'd been working on at RAND into creating scenarios for future economic, cultural, and technological developments. His work would go on to influence and shape the field of corporate scenario planning, most notably the Shell Oil scenarios team. Shell Scenarios was formed in 1965 and continues to produce scenarios to this day. The Shell team is among the most written about examples of in-house corporate futurists, in part because of the fact that the team largely validated its existence when one of its scenarios predicted the 1973 Middle East oil embargo.

Despite the significance attributed to Shell's ability to foresee this and other historical events, scenario planners tend to insist that the point is never to predict the future. Ted Newland, a veteran of Shell Scenarios, has been quoted as describing the goal of scenario planning as "trying to manipulate people into being open-minded." Creating safe spaces for uncertainty, opening minds to alternative possibilities—the arguments for scenario planning sound more like a case for the value of literature than an argument for its business value. The line between science fiction and scenario planning has been blurry since its inception. Aside from the

Strangelove homage, Kahn eventually became friends with (and commissioned short story treatments of scenarios from the renowned and borderline fascist) science fiction writer Robert Heinlein. Corporate utopias also gave way to literary dystopias: when asked about how his time as a publicist at General Electric shaped his career as a science fiction writer, Kurt Vonnegut famously noted, "The General Electric Company was science fiction." The feedback loop of science fiction and foresight strategist fact continues to this day. Most of those futures concept videos produced by companies like Microsoft are effectively short remakes of 2002's *Minority Report*, which continues to be a guiding light for product design (as well as a strategy for terrible advertising and a fantasy for efficient criminal justice) fifteen years on.

But in scenario planning certain futures remain beyond the pale, certain fictions remain outside the realm of plausibility. While Cold War and corporate scenario planners could imagine futures of doomsday devices and oil embargos, they didn't—couldn't—imagine a world without capitalism, not for

lack of imagination but because to end capitalism literally represented the end of the world as they knew it.

There's something almost too perfect about the fact that so much of this frame of rationally conceived futures would emerge in the wake of and in response to the existential threat of nuclear war. While eschatology could be considered either a subtopic of or the precursor to futurology (The Book of Revelations could, in theory, be interpreted as a strategic forecasting document), in any case the two are undeniably intertwined. But apocalypse signifies beginning as much as it signifies end—literally, it means to unveil, to reveal a new world or to reveal this world for what it truly is. That unveiling is what the finest science fiction does best, laying the groundwork not for a perfect airbrushed architectural render future but for the millions of weird, grimy, uncertain futures that may be imperfect and may be chaotic but are ours to create. Scenario planners and the corporate futures industry could not foresee the possibility that through the end of the world as they knew it, another might be possible.

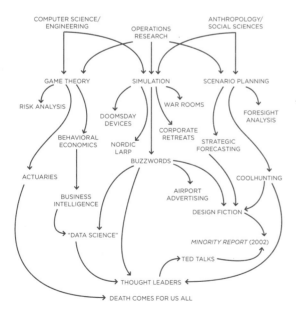

Ingrid Burrington, Operations Research diagram.

WHEN THE GRAVE-DIGGER WAS WAGED AS THE ARCHITECT

STEVEN COTTINGHAM

Once, the paradox of life within a necropolis was reality. Capitalism has left us with many confusions, especially where its dogmatic adherence to bottom lines and empiricals distort into the illogic of overshoot. How was it that a city built as a valorization of death in the age of austerity could house a still-breathing populace? When did life become death—at what point did the extraction of labor become full-body exorcism?

There was a moment in which housing legislation throughout the mainland was oriented to encourage those who would play the stock market with real estate. Utility prices decoupled from labor markets, ensuring that the costs of sustenance remained unrealistic to those upon whom the infrastructure depended. Dead labor in the form of rent and property value superseded labor-power to the extent that unceded, stolen land beneath the city earned more money than all the city's workers combined. Many developments sat unoccupied, owned solely for their value as investments. Over and over, affordable housing was demolished in favor of luxury towers which primarily housed capital, not bodies.

Metro Vancouver, inasmuch as it represented one of many neoliberal urbanities dominated by speculative developments, was Necropolis—a city of the dead.

We can understand capital as the ability to command labor, and labor is the turning of one's time into another's commodity. This accumulated time was the exploited life-force of those who did not partake in the profits enabled by their work. Towers in Gastown, Coal Harbour, and Metrotown took the form of crypts—not only for their housing of others' alienated life-force (which was also accumulated death-time), but also for the ways in which they dispossessed extant bodies.

Necropolis operated by collapsing the realms of body and ghost, making invisible that which was once corporeal while embodying that which was once intangible. Within Necropolis, capital congealed into physical forms while bodies were left unable to affect the land of the living. If, as the Situationists once noted, spectacle was capital accumulated to the degree it became image, then Necropolis was capital accumulated to the degree that it became undead.

Displacement served as part of an uninterrupted process of colonization and alienation. It is hard to locate Necropolis historically, because

although there was an urgency to the symptoms wrought by eviction, demolition, and gentrification, they formed only part of the perpetual crisis that was capitalism. We can note that the effect of living within a perpetual but dehistoricized crisis was to be constrained to one's immediate surroundings, incapable of looking beyond yesterday or tomorrow while subsistence was at stake.

Necropolis was a negated future: it represented the siphoning of forthcoming time for the sake of a precarious present. Dispossession occurred on the basis of an afterlife, a supernatural construct which found its corollary in the speculative nature of neoliberal real estate. Whereas threat of damnation once provided means to blackmail the laity, in Necropolis the commodification of sustenance held one's biopolitical future hostage. By this I mean that the body was condemned to spend time earning money for the commodities that keep it alive long enough to spend time earning money for the commodities that keep it alive. Under these circumstances, a moral order enforced power, asking for humility while forcing refuge in a non-existent future where one's forthcoming quality of life might match the agency of those who were presently in power. Individualist meritocracy provided the contemporary form for the myth of a divine-right to rule, while "too big to fail" institutions were bailed out and persisted via sheer faith.

Taken on its own, speculative finance was a ghost: an abstraction that operated beyond the corporeal sphere. Disembodied. But within Necropolis, speculative finance congealed into physical formations—tombs and crypts constituted a city where accumulated death was lionized above all else while reanimated fossils continued the vanguard of corporate/state expropriations. If a ghost could be understood as an entity excluded from the sensuous realm, then a body was its mirror: an entity excluded from the invisible, intangible realm where exchange occurred.

And yet, the body learned from the ghost. Yes, there were moments when the body haunted capital. The paradox of pecuniary power once meant that to possess a kind of wealth was to imbue oneself with a hypothetical power that drained as it was enacted. In the same way, the power afforded to Necropolis, the operation by which it was becoming-corporeal, was also the manner by which it was exposed. Complex logistical systems fell under occupations, where the mere presence of the body—which some have argued was its only remaining faculty—disrupted global chains of supply and extraction. Even an amateur historiographer can map this pattern again and again: just as all abstractions require form, so too all beasts have a belly.

THE LONG AND WINDING ROAD: RACE AND CAPITAL

LESTER K. SPENCE

LIVERPOOL, 1709. A modest thirty-ton vessel sails for Africa. By the end of the century, Liverpool is one of the greatest slave trading ports in the modern world. Between 1783 and 1793 alone almost 900 ships leave Liverpool for the Caribbean, carrying 303,737 soon-to-be-enslaved Africans, valued at over £15,000,000 pounds ($3.2 billion dollars in 2015).[1]

PARIS, 1791. The French Revolution begins, driven by political representatives made powerful by sugar revenues from Saint Domingue.

LOUISIANA, 1803. Napoleon sells the territory of Louisiana to the United States for a pittance, in order to help pay for the costs incurred fighting against the Haitian Revolution.

LIVERPOOL, 1809. William Ewart Gladstone (four-time British Prime Minister) is born to a major slave owner. Among his administration's accomplishments, the introduction of secret voting.

HAITI, 1825. Haiti agrees to pay France the sum of 150 million francs ($1.2 billion dollars in 2015) in exchange for diplomatic recognition.

LOUISIANA, 1827. The Louisiana State Legislature creates a property bank (the Consolidated Association of the Planters of Louisiana). The bank is among the first to bundle mortgages, in this case collateralized by slaves. The bank sells bonds in the US and across the Atlantic. Each bond gives the bondholder a "right" to a slave-sized amount of labor. Other states in the Deep South follow.[2]

GREAT BRITAIN, 1847. Thomas Affleck creates the *Cotton Plantation Record and Account Book*, publishing an edition every year until the Civil War. The now standard practice of depreciation is among the innovations Affleck helped pioneer.

GREAT BRITAIN, 1890. *Principles of Economics* by Alfred Marshall is published. In it we see one of the first articulations of the "supply and demand curve." Marshall discovers the concept studying the mid-nineteenth-century world cotton market—driven by slave labor in the American South.

Some would argue there is racism over there and there is capitalism over here. Perhaps loosely connected at best—a colleague of mine noted "everyone's

1 Eric Eustace Williams, 1993. *Capitalism & Slavery* (London: A. Deutsch, 1993).

2 Ned and Constance Sublette, *American Slave Coast a History of the Slave-Breeding Industry* (New York: Chicago Review Press, 2015).

a little racist" in reference to the Trump election as if racism were purely a matter of attitudes that can either be ignored or perhaps focus-grouped away. On the other hand some argue there is capitalism (maybe kinder, maybe a bit gentler) and then perhaps there's a racial variant of capitalism. Both takes are wrong. There is only capitalism. Along with the institutions (and knowledges) that make it possible (and that it makes possible), capitalism is constitutively racial.

Eleven years before Liverpool sends its first vessel to Africa, Englishmen combatting British trade monopolies get one of their first and most important political victories—the right to trade in slaves. To them this right was as important in the fight for the natural rights of man as the vote. The economy that enabled the French to overthrow both their aristocracy and monarchy was driven by slave colony revenues— Saint Domingue in particular. We take the "supply and demand" curve and depreciation for granted, not recognizing that both were "discovered" as a by-product of King Cotton. Although the seeds of what we now think of as "race" existed in Europe before this moment, what we see with the slave trade is the "perfection" so to speak of a system of human classification that is systematically used to subjugate entire nations of people. It's the wealth from this trade that makes innovations in political theory (the social contract theorists all developed their work during this period), economics (Adam Smith's *The Wealth of Nations* is written during this period), and industry (the Industrial Revolution) possible.

In the modern moment we can't quite understand the neoliberal turn much less the specific Brexit and Trump reaction to it, without understanding the work race performs. In the United States and elsewhere, inequality decreased drastically from 1920 to around 1968 or so, largely because of political action—the New Deal created a new social contract between Americans and the government that gave them old age insurance (Social Security), unemployment insurance, welfare, the right to organize, and a minimum wage. This and the civil rights movement gave working class citizens a larger share of wealth than they'd ever received. But starting in around 1970 the group we now identify as "the 1%" began to claw back these gains. We now have higher levels of inequality than we had during the Great Depression. How do we explain the rise? Well, we can turn to politics again, but there's a problem. The United States, if not a democracy, still depends at least a little bit on the consent of the governed. People had to somehow assent if not consent to a set of policies that would end up increasing their anxiety while flattening their wages and reducing their benefits and possibilities of retirement. How does this happen? A coterie of intellectuals, think tanks, foundations, and political elites fuse ideas about cultural dysfunction, race, and civic worth together. Welfare, progressive taxes, rehabilitative policing, and unions all become racialized. Attitudes supporting each drop like a rock, particularly among middle and lower income whites.

Now if the Haitian Revolution tells us anything, it's that resistance is possible. But further, creating a new world is as well. But only if we plot and plan with the tools we've fused, the ideas we generate, and the joint interests we forge.

PERHAPS IT IS HISTORICALLY TRUE THAT NO ORDER OF SOCIETY EVER PERISHES SAVE BY ITS OWN HAND.

JOHN MAYNARD KEYNES

EMANCIPATORY POLITICS MUST ALWAYS DESTROY THE APPEARANCE OF A "NATURAL ORDER", MUST REVEAL WHAT IS PRESENTED AS NECESSARY AND INEVITABLE TO BE A MERE CONTINGENCY, JUST AS IT MUST MAKE WHAT WAS PREVIOUSLY DEEMED TO BE IMPOSSIBLE SEEM ATTAINABLE.

MARK FISHER

Maker unkown, Parchman token, date unknown (artist's rendering).
Obverse: Miss. State Parchman Penitentiary
Reverse: Good for 50¢ in Trade

This prison token from Mississippi State Penitentiary, also known as "Parchman," was given to a St. Louis resident by his grandfather, who probably acquired it through a state worker who had dealings with the prison.

Prisons often had a commissary or canteen where inmates could purchase small disposable goods, and some even produced their own coinage or "tokens" in order to facilitate this exchange. In this system, any money found in an inmate's possession at the start of their term, or received while in prison, would be credited to their account. Then, from that account, they would be allowed to draw funds, in limited amounts, in the form of prison tokens for use in the canteen or commissary. These came in denominations ranging from 1 cent to $5, and would be made of such materials as aluminum, brass, bronze, nickel alloy, or white metal. Over the years, circulating forms of exchange gave rise to problems much like those that would have been caused by the use of real money. Because they were transferable, tokens and similar substitutes were used by inmates not only for the purchase of candy, cigarettes, and other personal items, but also for gambling, illegal purchases, and extortion.

Although use of official currency was forbidden in US prisons, sophisticated alternative currencies sometimes developed, with certain common items used as currency. Cigarettes were a classic medium of exchange, but after prison tobacco bans, postage stamps became a more common currency item, along with any inexpensive, popular item with a round number price such as 25 or 50 cents.

To solve the problems caused by both in-house coinage and alternative currency exhange, many prisons eventually turned to forms of currency that could not be exchanged between inmates, such as trackable coupon books and personal accounts.

Capitalism in the twentieth and twenty-first centuries in the United States thrived off of the cheap labor of prison inmates, just as in previous eras it profited from slavery. The prison network itself became a for-profit "complex" dominated by a few large corporations. And yet even in these oppressive conditions, among people with no little hope of escape from a seemingly all-powerful system, small acts of resistance, novel social organizations, and glimmers of non-capitalist exchange emerged.

Allah El Henson, sketch of Blake Fall-Conroy's *Minimum Wage Machine*, 2016.

HERO OF CAPITALISM

ADAM SMITH
1723 – 1790
BRITISH PHILOSOPHER AND ECONOMIST

"The work done by free men comes cheaper in the end than the work performed by slaves."

Riiko Sakkinen, *Heroes of Capitalism* series, 2016.

THE CONCEPT OF PROGRESS MUST BE GROUNDED IN THE IDEA OF CATASTROPHE. THAT THINGS ARE "STATUS QUO" IS THE CATASTROPHE. IT IS NOT AN EVER-PRESENT POSSIBILITY BUT WHAT IN EACH CASE IS GIVEN.

WALTER BENJAMIN

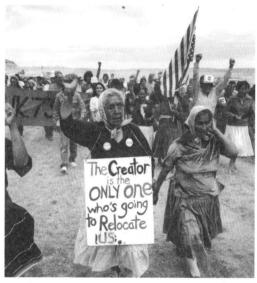

Dan Budnik, *The Creator is the only one who's going to relocate us*, 1970. © Dan Budnik

A stand or rack outfitted to display a range of sunglass styles, typically for merchandising and selling eyewear.

Untitled mousetrap design from early twentieth-century US catalog.

AS CAPITALISM DIES

HEATHER DAVIS

We were told we lived in the best possible world. There were so many things, so much abundance. We believed our children would have more than we had had. For many, that meant an end to deadening poverty. But this increased wealth was often only evaluated in terms of our material things: cars, houses, clothes, electronics. It seemed that these were the purposes of life, these things that filled our homes. And for many more, these things were an undue source of pain, when we realized that they were not for us. That the promises of unending growth and unending progress really did have limits. That more and more people were being "left behind" while the rich consolidated their wealth in a historically unprecedented fashion.

For those who resisted, who wanted ways to evaluate being in the world that weren't about material goods or growth, it felt like capitalism was never going to end. Even though it had only been going on for a few hundred years (a blip in history), it had taken so much. It ate everything around it: the plants and animals and people and ancestors and relations and love and compassion. Some managed to escape, to build lives and communities of resistance that were beautiful and kind, that were governed by ideas of collective justice and freedom, that understood the reciprocal and caring relations that sustain us, that can govern our interactions with the earth and all our kin, human and non-human. Some were sucked into the dream, eaten by their own depression

at the realization that the dream was not made for them. So many suffered immeasurably fighting or succumbing to the inhuman conditions that made up that world. And I haven't even mentioned yet the whales and the clams and the foxes and the trees and the plants whose names we had lost or forgotten.

I remembered a dark joke someone once told me about colonialism: that the first 500 years were the hardest. It seemed that the same thing could be said about capitalism. Except, thankfully, it died before then. But it was a hard death. When it did die, it took so many things with it. It thrashed and held on. It refused to let go. It shrieked and yanked and panicked. It had no concept or idea about what a good death might mean. Dignity was always beyond its grasp.

It was hard to recompose with what was left. We had lost so much. So many ways of living, so many non-human kin, so many people. Instead of good soil, good dirt, or shit, the regular byproducts of life and culture that could easily be composted, easily be recomposed, it left in its wake these things that refuse to die. Even if the economic system known as capitalism is gone, even if the subjectivities and collectives that made up that system, both in resistance to and in service of it, were also gone, the materiality of capitalism remains.

All of the metals that were dug up, once indexed to the preciousness of commodities, brought to the surface because of paper mills and mining and dams,

now circulate through our bodies and our waters. The chemical companies left their marks too. Our bodies are sometimes still considered so contaminated that they are deemed hazardous waste. The plastics and persistent organic pollutants are still here. DDT and PCBs still circulate in our world. The radioactive waste from nuclear plants still leaks and spreads. Each of these things still affects our health and our birth rates. We still have to be careful about where we grow or harvest our food. These chemical signatures will be written into the earth long after humans have evolved or died off. Capitalism turned the earth inside out, and consumed the rich stores of energy that had taken hundreds of thousands of years to create, within a few decades. It ate time itself.

We tried to fold the chemical things back into the earth, along with the heavy metals in the water and carbon dioxide and methane in the atmosphere. And they will fold back in, eventually. But the extension of capitalism through the body of the earth means that even though we no longer believe in profit above all else, these materials still wreak suffering and death. We are haunted. We are haunted by these material legacies, just as we are haunted by all the loss.

The process of healing that was necessary in the wake of all this devastation meant recalibrating to time. Instead of continuing to live in geologic time, we now live in biologic time. We use the materials that can live and grow and die within our lifetimes. We still think and dream of the ancestors and those to come. We ask them for advice, we try to not repeat their mistakes. But we do not take from them, we do not take their food or water or air, we do not take their future.

We have learned that it is not that capitalism has no outside, it's that our relation to the earth has no outside. We are everything that moves and breathes and doesn't breathe and stays still on this planet. And we would have been so much more if it had never existed.

DAYS OF 2017

KEVIN KILLIAN

The artifact you are looking at now was manufactured centuries before the republic reorganized itself in the tenth or eleventh night of Floreal in the year two after revolution. Hundreds of years, or so we estimate, each one etched by green acid into the complex weave of cotton and linen. Historians tell us that here was as much cotton—twelve ounces—in a pound of dollar bills as there was in the amount of underwear an average American wore in a week. The bills were weighed only at customs, but the fantasy persisted that each one represented, at a significantly lower density, an equivalent amount of gold, supposed to rest somewhere in the foothills of Kentucky, one of the so-called slave states devoted to progressive labor and capture of workers by chains and whips. See Fort Knox, the movie set erected for the third James Bond film of what they called the postwar period, whose plot was based on an annual attempt of black slaves to seize the storage units of the monetary systems of the world in 1963 or 1863.

It was around this time that the notion of "archive fever" was bruited by a small band of French impudents, led by the filmmaker Jacques Tati and his frequent star and muse, Soviet-born Anna Karenina. Archive fever and its companion illness, hauntology—the near homonym of the derided "anthology"—took Europe by storm in the wake of the tragic war between the Algerians and the crash of the zeppelin into the tower of light erected by Deleuze, then known as the "French Gordon Matta-Clark" (both artists cut apart the intellectual world during the Situation period). "Hauntology" began to assume physical proportion as the CD came into being, together with digital technologies, each one whispering of planned obsolescence. By the turn of the twenty-first century no one was alive who knew how to program a VCR or play the once omnipresent video game *Myst*.

Inside the archive at the heart of *Myst* (the gamers' acronym for "Make Your Shit Tribal"), an enigma persisted, and the game was deliberately designed to play slower than paint drying. This gave players the chance to decipher on-screen objects which might be tools to save your life or to fill you cold stone dead. "Slow cooking" became the rage, as players reported average dial-up call-in times of up to half an hour. The dollar bill in the artifact wall was placed there as apotropaic warning of the danger of gaming so slowly your calves and thighs might atrophy into stony pretzel sticks. The image glimmers and grows; your shit was made tribal, but at what cost?

Social scientists noted the vast numbers of babies called Ryan and Jason, conceived in the era of slow cookery and in-flight insemination. You could watch really long movies like *Shoah* (a 1976 hit for Jerry Lewis), its sequel *Whoa!*, or *Roots* (the miniseries, with Ruta Lee) or in the same amount of time, you could watch one image slowly expand from a one-pixel membrane implanted into

your screen, into a larger one, still small by later standards. You could write a sonnet while that pixel got big enough to see. You could have sex. You could write a sonnet, have sex, prepare a three course meal, and clean up, and that glimmer on the screen would still be only the size of your smallest fingernail. Multiversity tasking made sense then, and the feeling that one didn't really have to be aware of anything on the screen, much less in its periphery. It was in that decade in fact that the periphery became more important than the spectacle. The thing you wanted to watch became the background, the Muzak, the incidental odor, the ambient sound that Brian Ono had espoused after breaking up the Roxy Beatles.

Thus the dollar bill on display here represented a sort of faith-based economy, symbolized effectively by its faded green color. Green was then said to be the color of "nature," and so the bill, so often used in commercial undertakings, was designed to resemble the common North American leaf. In the US there were hierarchies of cuisine, but eventually the upper middle class people, aping their antiquey Neanderthal elders, had begun eating a plant-based diet made with its fair share of leaves and grasses. On his eighteenth birthday, the male heir threw himself a dieciocho—a traditional coming of age ceremony—and families and chamberlains gathered around his anus to stuff it with leaves, pickles, grasses, and joints. He was judged to have successfully made his shit tribal. President Clinton signed the AMBLA Act—the Man Boy Free Trade Act—in 1993, lifting the borders between culture and trade, man and boy, making all of North Americxa one severely constipated continent. Notice the Latinx language sprinkled across the surface of the bill. "E pluribus unum." Though much of our knowledge of Latinx culture ended in the 2020s, as the great wall went up and cut off the USA from its roots, linguists believe that the saying meant something like,

"Hey! It's one big party!" Over the Mayan pyramid hovers a seeing eye, the panopticon of French culture, watching over the wall for signs of counter-revolutionary disquiet in the Latinx countries, and around this form letters spell out, "Annuit Coepis," that is, "Aunt Shall Spy on Us."

Thus capitalism spread and one by one the lights went out, and yet here we see the dollar itself, rather like the plant-based forms called leaves, a rhomboid without threat on its face. Urban audiences used to advise their children that it was "all about the Benjamins," and it was Walter Benjamin's 1950s TV show about an Angel of History—played by Hungarian sex kitten from Mars, Zsa Zsa Gabior (the "girl with two Zsas") to which they were referring, in the days of 2017 when the angel took flight.

RACE: A POST-CAPITALIST PERSPECTIVE

JENNIFER A. GONZÁLEZ

Some of us may remember when the color of skin and the shape of facial features were considered important traits for establishing social rank. Capitalism was at its peak, and very few people questioned the inevitability of its ubiquity. There was a general sense under the monetized logic of neoliberalism that those who earned less money were less worthy. Racist attacks targeting people who looked different were commonplace in the news media, film, television, literature, and advertising as well as on the street, in workplaces, in places of worship, in places of commerce, in schools, at tourist destinations—indeed, in every part of life. For some, racism was a kind of entertainment: people found joy in cruelty, pleasure in bigotry, humor in derision, strength in hatred. Despite the paradoxical and contradictory nature of these affective states, they were shockingly common. Capitalism was always inseparable from slavery.[1] The British slave trade created the economic conditions of possibility for the development of the British Industrial Revolution, as well as the American Industrial Revolution. It created a model in which fantasies of cultural superiority gave people the right, even the duty, of subduing others that they considered to be inferior. A strange and convoluted logic, inherited from centuries of Judeo-Christian prejudice, coupled with greed and invasive, colonial zeal, led Western European countries down the path of nearly worldwide domination and destruction.[2] Empire, as a military, financial and intellectual project, was inseparable from the ideological frameworks of ethnos and race, "civilized" and "savage," "national," and "cosmopolitan" rights.[3] These conceptual and material "differences," when translated into economic and labor inequities, were the bedrock of capitalist accumulation.

As long as workers' bodies could be dominated, and as long as there was a ready supply of new bodies, whether through slavery, colonialism, or class hierarchy, capitalism thrived thanks to cheap labor and wide margins of profit. For hundreds of years this model of domination and profit, where violence and military intervention supported a wealthy elite and their unquenchable thirst for accumulation, continued as if inevitably. Despite centuries of protest, despite union organizing, despite experiments in alternative economies, capitalism proved to be robust as a system of thought and action.

In fact, the inequalities made possible by the ideologies of racism led to an

1 See Eric Williams, *Capitalism and Slavery* (Chapel Hill: University of North Carolina Press, 1994).

2 See Bartolomé de Las Casas, *A Short Account of the Destruction of the West Indies*, 1542.

3 See Anthony Pagden, *The Burdens of Empire: 1539 to the Present* (Cambridge: Cambridge University Press, 2015).

untenable situation; dominant ethnic populations relied heavily upon the labor of subaltern ethnic populations that they exploited to the point of exhaustion. This was the case across Western Europe as well as in the Americas, and took place nationally, and internationally (when "nations" still organized human populations and geographies). Internally, countries would enact laws that resulted in the distribution of the lowest paid jobs according to implicit or explicit racial hierarchies. Externally, they would erect borders and fences to create autonomous economic zones. Differentiations among language accent, skin color, ways of dressing or heritage were forms by which this separation would take place. Even ethnic minorities with qualified skills, advanced education, and excellent training were denied gainful and high level employment on a regular basis because of their "race." This apparently illogical and irrational behavior on the part of employers was in fact part of capitalist logic. Workers were needed to fill low-paid professions; racism was one of the primary means of maintaining a predictable and consistent subaltern population who would be forced to take such low-paid work precisely because all other forms of work were denied to them.

In the case of California, for example, before the Great Climate Change, descendants of Northern Europeans relied on the cheap labor of descendants of Indigenous Americans, who were largely Spanish-speaking migrants from countries to the south. Before the abolition of national borders, these workers were easily manipulated into working for substandard wages. The constant threat of deportation, detention, imprisonment, or death created conditions different from but similar to American slavery of the eighteenth and nineteenth centuries. Access to education for these workers was regularly suppressed by laws passed—such as Proposition 227 in 1998—which restricted elementary schools to English-language only instruction. Fortunately this law was repealed in 2016 which led the way, some decades later, to the New Trilingual Movement that swept the Western hemisphere. Similar laws, such as the California Alien Land Law (1913) that single out specific populations to exclude from citizenship were also intended to prevent ethnic minority groups from collaborating with each other to resist repression.[4] Many more examples exist of the ways segregation laws, whether in relation to housing or education, created separate and unequal communities that were thereby primed for economic exploitation.

Maintenance of racial hierarchies was equally dependent on the ideology of individualism. As long as capitalism could promote the idea of freedom as belonging only to individuals rather than groups, and promote the concept of private property, luxury and possessive rights, then the important work of cross-racial identification necessary for the elimination of racism and classism was held in check. Indeed the critical barriers to cross-racial, cross-sexual and cross-species identification put in place by the binary logics dividing the world into men and women, black and white, taxonomies and "types," categories and phyla inherited largely from Western European scientific and philosophical traditions, led to the rapid expansion of capitalist domination of both the human and natural environment; *divide and conquer* could not have been more explicitly articulated than through the capitalist ideologies of the twenty-first century.

Neither animals nor plants, oceans nor streams, deserts nor mountains, were safe from the rapacious appetite of capitalist extraction. Whole ecosystems were completely destroyed, denuded of life, filled with toxic waste, all for the sake of profit. Many humans died in the effort to protect the environment, and many were imprisoned. The

4 See Mark Brilliant, *The Color of America Has Changed: How Racial Diversity Shaped Civil Rights Reform in California, 1941–1978* (New York and Oxford: Oxford University Press, 2010).

nadir of capitalist exploitation laws was the International Containment of Conscience law (passed by the World Bank Court in 2024) that made it illegal to defend or speak out in support of someone from a different race, ethnicity or animal species, or to try to protect any natural resource or ecological system. Today, we celebrate the heroism of the tens of thousands who fought against this law and participated in creating the conditions of coalition-building across ethnic and species communities that eventually led to the abolition of financial markets, monetization, profit-driven enterprise and inequality of wealth and resource distribution. Without a capitalist rationale, even racism declined rapidly. It appears now only rarely as one of the "post-capitalist pathologies," identified by the Integrated Medical Professions. Our species' modest but ongoing survival of the Great Climate Change was in no small part due to the activists and visionaries whose proposals for Collaborative Living were once considered "radical."

ONLY A CRISIS—ACTUAL OR PERCEIVED—PRODUCES REAL CHANGE. WHEN THAT CRISIS OCCURS, THE ACTIONS THAT ARE TAKEN DEPEND ON THE IDEAS THAT ARE LYING AROUND. THAT, I BELIEVE, IS OUR BASIC FUNCTION: TO DEVELOP ALTERNATIVES TO EXISTING POLICIES, TO KEEP THEM ALIVE AND AVAILABLE UNTIL THE POLITICALLY IMPOSSIBLE BECOMES THE POLITICALLY INEVITABLE.

MILTON FRIEDMAN

Playskool, McDonald's playset, 1974 (artist's rendering).

In the mid-twentieth-century United States, "fast food"—food that was typically low in nutritional value and prepared and served very quickly—was popularized by the hugely successful retail chain McDonald's. At its peak, McDonald's was the world's largest chain of hamburger fast food restaurants, serving around 68 million customers daily in 119 countries across more than 36,000 outlets, and with 1.9 million employees was the world's second largest private employer. With the expansion of McDonald's into many international markets, the company became a symbol of capitalist globalization and the spread of the American way of life. In fact, in his autobiography *Grinding It Out: The Making of McDonald's*, Ray Kroc, who is credited with the fast food chain's expansion, described the company as his "personal monument to capitalism."

On display is a portion of a McDonald's playset from 1974. The full McDonald's playset, made by Playskool, also included a sign bearing the company's famous "golden arches" logo, seven "play friend" figurines (manager, crew, and customers), trays that fit under the play friends' chins, cars to take them to a parking lot, an outdoor eating area with patio table and merry-go-round, and a cash register that rang when tapped. The set was designed to closely match the design and decor of 1970s-era McDonald's restaurants, and was one in a series of "Familiar Places" playsets produced by Playskool, which also included a Texaco gas station and a Holiday Inn hotel.

McDonald's was known for its aggressive marketing targeted towards children and ethnic minorities. The company's prominence also made it a frequent topic of public debates about obesity, corporate ethics, and consumer responsibility. Apart from influencing consumer preferences, toys like these often served as a kind of psychological priming for the world of adult life—the built environment, infrastructure, and economic systems which new members of society are expected to assimilate into and accept as given. In this case, the "normal" world being imagined by users of this playset was structured firmly around the burning of fossil fuels, low-paying wage labor, and the unsustainable agricultural practices of industrialized food systems.

Ironically, the tiny plastic toy versions of institutions like these will far outlast any of the thousands of the brick-and-mortar buildings they are modeled upon. This specimen is one of thousands that are hidden in dusty basements or buried in landfills, waiting to be unearthed by future archaeologists. Some people living under capitalism who encountered objects like this shared the conflicted sentiments of the previous owner of this toy, who said: "I don't like capitalism, but I like the shiny things it produces."

THE MOST VITAL FUNCTION OF MUSEUMS IS TO BALANCE, TO REGULATE WHAT WE MIGHT CALL THE SYMBOLIC ECOLOGY OF CULTURES, BY PUTTING FORWARD ALTERNATIVE VIEWS AND THUS KEEPING CHOICE AND CRITICAL DIALOGUE ALIVE.

NEIL POSTMAN

Plastic bags were once commonly used as mobile containers for food and other goods in the United States. These representations were fashioned from animal hide by Jordan Bennett.

Untitled mousetrap design from early twentieth-century US catalog.

HERO OF CAPITALISM
HENRY FORD
1863 – 1947
AMERICAN BUSINESS MAGNATE

"It is well enough that people of the nation do not understand our banking system, for if they did, there would be a revolution before tomorrow."

Riiko Sakkinen, *Heroes of Capitalism* series, 2016.

Dan Budnik, *There is no word for relocation in the Navajo language; to relocate is to disappear and never be seen again*, 1970. © Dan Budnik

THE PURE PRESENT IS AN UNGRASPABLE ADVANCE OF THE PAST DEVOURING THE FUTURE. IN TRUTH, ALL SENSATION IS ALREADY MEMORY.

HENRI-LOUIS BERGSON

Artist rendering of a museum display of plastic resin "monobloc" chairs, which achieved global ubiquity due to their ease of production and use.

Pens advertising various pharmaceutical companies, from the collection of Dr. Jeffrey Caren.

BETWEEN THE ARCHIVE AND THE STREET

CALUM STORRIE

Most people would think of this as a front doorstep, but as the Director of this facility you see it differently. Standing here, at once both inside and outside, in both London and the Museum, you think about the particular geometry of the place. The galleries are divided by a thoroughfare. You have designated this as non-static exhibition space where the exhibitions have a duration of seconds. Turning either way you will enter the South Gallery. If you cross to the other side (it looks just like a street and there is no dividing wall) you will reach the North Gallery. You think about turning right where the dense archaeology of the basement archive from which you have emerged is replaced by a rather more diffuse environment. You can see the ordinary clutter of the street: railings, pavement, signs, traffic, and the facades of buildings. But this so-called street is your Museum.

Walking through its galleries there are many ways to approach the exhibits. It is possible to read the narrative horizontally; one number following another, each door opening onto a variation of the world you yourself inhabit. This imagined experience is at once familiar and strange. Recalling that Christopher Alexander essay about how cities are not trees but 3D matrices, you have to remember that there is, at once, a linear reading and, simultaneously, an infinite

number of networks. The people who have walked this floor, the people who have lingered before the cases or dwelt in the houses are both spectacle and spectator. It is possible to read vertically, diagonally and at random. And through time as well as space. You wonder if you need to start raising money to get a roof built over the old place. There is no problem with visitor numbers and no one seems to care about the microclimate. But you are anxious that visitors don't really look at the exhibits as they seem to spend much longer in the cafes and the pub. Was it a good idea to have a pub in the museum? When you came here there were five of them but museum visiting patterns have changed since then and it has been necessary to revise the customer services. Not that you really had any control over any of this.

It is both the problem and the advantage of this place that as Director you have to adapt the museum to the displays that present themselves. It would not, for instance, have been your decision to have that case installed in the North Gallery with the diorama of the human birth scene attended by animals. Surrealism has a season though, so you have to live with that. By the time you get around to writing a label it will be gone, at least until next year— and anyway, shouldn't the Curator of Mythology be in charge of that? You

would, of course, have to hire one. You are, however, happy about the vitrine at the East Entrance—the mannequin with the necklace of hair-rollers, the black wig, the one white arm and one black arm seems to "speak to" the neighborhood and, after long consideration, you decide to leave the display unlabelled; its relevance, no matter how oblique, best left unspoken.

Looking out from the Archive doorway, you can see the postal exhibit. It was only when you were asked to give a lecture on this that you became aware of its provenance. At the time you were Acting Director, but realizing that the pillar-box had been made in the town in Scotland which you grew up it seemed that this museum was, somehow, the place to be. In raised letters on the black cast-iron base of the postbox it said "Lion Foundry." You could remember exactly where this was in the town: on the riverbank, over the hill from the Black Bull Cinema. The cinema had the name of a former pub as, back in the 1960s, this was a dry town. "This object has been where I have been," you thought, "and I followed it here." Not long after this you were commissioned by the Trustees to document all the wall texts in the museum. This involved writing down every word or number you could see. It was too cold to do it all in one day, so the North and South Galleries were recorded on separate occasions. In fact, they were done on different days about nine months apart, but this didn't bother anyone as it was not entirely clear at the time what the point of this Perecian exercise was. Maybe it is time to revisit this document, as the second part was completed nearly three years ago and the galleries have undergone many changes since then. Referring to the notebook that you have in your pocket, you can see that you recorded only an abbreviated form of the wall case devoted to "Oneness: Code of Life Now Revealed." This exhibit has now been violently removed and this is another

reminder that you need to do something about the archive of photographs of this display, especially as you suspect that the curator did not think of recording its various manifestations.

Do the curators know what they are involved in? Sometimes it looks like they are producing these exhibits as if they were personal projects. Take the ironmongery display. This is an agglomeration of tools and building materials stretching back for decades. But the curator, often in attendance, isn't particularly interested in sharing any of this with the occasional visitor. Instead, he relies on his assistants to pull exhibits out from the reserve collection and lets the visitors handle them. You know that the occasional piece leaves the collection in this way but you think that's best forgotten. The continuum of use-value supersedes the alienation of aestheticization and you are not sure how the curators could survive without the odd "under the counter" transaction. Luckily, accreditation is not one of your concerns. You wonder if anyone has swept the gallery floors this morning. You hope not.

GLOSSARY

dry town. One in which the sale of alcohol was prohibited.

ironmongery. Hardware.

pillar-box. Mailbox of columnar design in cast-iron with black base and red top. In London, these often have two slots, one for first-class and the other for second-class mail.

pub. A public house, bar, tavern, inn, ale-house, local, or boozer.

A MUSEUM OF CONTRADICTIONS

AN INTERVIEW WITH LUCY LIPPARD

In the lead-up to the opening of the Museum of Capitalism, museum curators posed a series of questions to Lucy Lippard— author, art critic, curator—whose work on extraction, tourism, art, and politics have been an important point of reference. Their exchange, conducted via email, is excerpted here.

MUSEUM OF CAPITALISM We always have to start with this simple question, as it's been an important part of our early work on the museum, and you represent a kind of focus group of one. What would you expect to see, or what would you like to see, in a Museum of Capitalism?

LUCY LIPPARD I'd expect to see lots of excuses and glowing reports about how wonderful capitalism is for all of us as we stand with our mouths open, hoping for some trickledown. And maybe a dimly lit Marxist or oppositional corridor on the way to the restrooms?

MOC The Museum of Capitalism is in a tricky place with regard to its supposed subject. The common responses "Isn't capitalism already a museum?" and "Aren't museums already capitalism?" are of course true, in a sense, and yet museums as institutions can play interesting roles and do interesting things in the world, things that might have some bearing on the status of capitalism, as curators or museumgoers. It's here, in this relation between museum and world—inside and outside—where the MOC is positioning itself, walking a tightrope. Any thoughts on how to walk this tightrope, or how to reach the other side?

LL It has to be a museum of contradictions? As the US descends into chaos, we are learning yet again the power of humor, satire, parody. Maybe the more confusing it is, the more thoughts it will provoke.

MOC The inside/outside question relates also to the famous art/life problem, which you have considered in your writing. The Museum of Capitalism, like other museums, attempts one sort of fusion of art and life by displaying life as art, or at least as artifact. When seemingly everything is art (or is capitalism), do the terms of the art/life binary somehow shift? Can we learn something here from vernacular museums or other projects where art and life have been blurred?

LL The everyday can't be displayed unless it's replaced every day. (Maybe that's a strategy, but a labor-intensive one better served by the Internet?) It's one of those social energies that can't be recognized as art because its moment

has already passed. Dispersion may be the only choice for an anti-museum or memorial—something (art?) temporary, unobtrusive; non-monumental reminders in the public domain/marketplace, pointing out who's gaining from what we see in shop windows, or tall buildings, or in banks, or online ... and who's losing. A museum in the streets with art that hits people as they ratrace by. Or at least (for an existing institution), redistribution of its basements full of unseen and never-to-be-seen wealth to appropriate community centers and small local museums or schools (as suggested by the Art Workers Coalition's Decentralization Committee in the late '60s). Or on a more positive note, stuff that points out a few points of honesty and fairness in our commercial geography?

MOC You've written a lot about place and what it means to visit. We've been thinking a lot about the places where the museum manifests, and sites that may be considered part of its exhibitions. Any thoughts on how capitalism affects places, or affects our sense of place? And how artists and others have responded?

LL Capitalist globalization divorces us from any responsibility we might feel locally. Its homogenization implies local powerlessness. Artist Pierre Huyghe has said "maybe elsewhere is becoming everywhere." Capitalism affects every place, even a little village in New Mexico that is meeting with the county about how to achieve a "revitalization" (i.e. a local economic base—difficult in a tiny bedroom community made up of some wealthy retirees and some locals living in poverty and a few in between, some of whom are artists). Capitalism is all we know. Are nonprofits non-capitalist?

MOC Right. Perhaps because capitalism is all we know, something always feels wrong about memorializing

anything, having the nerve to freeze something in time and assume the distance needed to properly objectify or historicize it, let alone to give it form. Can a proper memorial or monument ever be built? And is there a remembering that is not also a forgetting of something else?

LL I don't know how you'd document or memorialize the dismantling of capitalism's own museums (though we would miss them).

MOC In your book *Undermining,* you say "We don't yet commemorate our eco-tragedies, leaving the task to artists, photographers, journalists, and science fiction." What do you think a more widespread public commemoration of eco-tragedies might look like?

LL Any eco-memorial would, again, have to be on site. At Flint's water works? Or at the building where decisions were made to lethally pollute that city's water? Or at the Courthouse or on the sidewalk next to the home of the decider? Or a fountain of leaden water? So many devastated sites are hidden from public view, and for a reason. (This is where the Center for Land Use Interpretation comes in.) A guide book to eco-tragedies on your neighborhood? Your county? Your state? Dioramas of gigantic mines? What would an artist do?

MOC The curator's traditional role of caretaking is reflected in the etymology of the word. This role has expanded as museums started doing more than collecting, and as the line between artist and curator has been blurred, curators becoming "producers" and even stars. Outside the museum setting, the term has expanded into popular usage to refer to lifestyle consumption—to the point where things like online listicles and sandwiches can be "curated." How might today's "curators" become caretakers in a larger sense?

LL Curators are no longer caretakers, they are selectors, or gatekeepers, as beholden to capitalist royalty as any other subject. But even wishy washy attempts to be subversive can encourage more robust resistance. (What's a listicle? Hybrid of list, popsicle, and testicle?)

MOC It might be fair to say that preconceived notions of ecology—as something distinct from economy, i.e. capitalism—can limit our ability to make art about it. The discourse emerging around the Anthropocene seems to be shaking things up a bit, shifting some long-held dualisms like nature/culture. Does this shift things also for artists and others involved in making exhibitions?

LL In a curious sense the notion of the Anthropocene (in which nature and culture are inextricably entwined) confirms Manifest Destiny, though it may also raise consciousness about how power corrupts. We (humans) see ourselves as the beneficiaries, adversaries, and rulers of nature, forgetting that we're only a self-destructive part of nature. The question is whether we're going to stand by and watch the Anthropocene perform us into oblivion or whether we're going to take charge of our namesake.

MOC Making a museum is a tricky business. I think we try to shift the contexts in which art appears, and to encourage what you call "social energies not yet recognized as art." Can you give any examples of this, past or present, that stand out for you?

LL Museums have to pay rent. To whom? There is inevitably a built-in irony to any building containing the critique of capitalism, which is why all my suggestions are for a non-site museum that establishes itself on the sites that matter.

MOC Do you have any thoughts on the way capitalism works in the so-called art world? (Or the way that the art world works in capitalism?)

LL Suffice it to say that the so-called art world is a product of capitalism, oligarchy, inequality, desire, and maybe hope. Artists in this sandbox are no freer than anyone else, though their screams may be heard when others' aren't. I'm reminded of the years that *Guernica* was hung in the Museum of Modern Art, on loan until Spanish fascism fell. The wall labels were a feat of apolitical commentary on a passionately political artwork, mentioning nothing about Picasso's communism, etc. Artists trying to be honest just put it out there and let the pennies fall where they may. Artists working their way beyond capitalism are punished because they get a lesser share of the profits. Hold-out heroes are sometimes rewarded in old age or after death. Voices of "dissent" are grudgingly acknowledged once their impact has been softened by inclusion or co-optation, or eventual irrelevance.

SACRAL ART, COURTLY ART, BOURGEOIS ART… AND THEN…

SAYLER / MORRIS

In reviewing twentieth- and early twenty-first-century cultural and art theory, we are struck by the prevalence of the phrase "late capitalism" or some variant of it. As early as 1902 the tantalizing idea emerges that "capitalist" or "bourgeois" society will move through set stages of development, propelled by its own inner logic, and then ultimately will self-immolate. This raises the question of whether such theorists thought they were condemned to a mode of waiting for the promised land of empathetic governance and ecological consciousness or whether they could actively work in ways themselves to hasten the demise of capitalism. We see now that writers and artists who trafficked in the phrase "late capitalism" frequently managed to cannibalize their own optimism with grim ceremony. They were trapped by their own methods and, indeed, their own snobbery.

Take Peter Burger as Exhibit A. He noticed something very important: the erosion, in macro-historical terms, of Western art as a collective enterprise. He mapped it all out. There was Sacral Art, Courtly Art, and then Bourgeois Art, all in a straight-line historical continuum. Art, Burger noticed, used to come forth from the collective and its purpose was to reinforce the collective, but gradually art ebbed into a solitary act by "genius" producers. This art bolstered the imagined "inner life" of its individual viewers as a form of retreat from the means-ends drudgery of the workaday world, with the concomitant effect of producing unique luxury items, the retail value of which was wholly contingent on aura conjured through marketing techniques.

Whatever the limitations of this hyper-generalized schema, Burger's enduring insight was to break down our understanding of art into three components: its production, its reception, and its "purpose or function."[1] His chart looks like this:

	Sacral Art	Courtly Art	Bourgeois Art
Purpose or function	cult object	representational object	portrayal of bourgeois self-understanding
Production	collective craft	individual	individual
Reception	collective (sacral)	collective (sociable)	individual

So we have here a step toward a truly useful political sensibility: the recognition that the present is not a natural state, but rather contingent. The art of 2002 is not the art of 1702, and the art of 1502 is not the art of 502, etc. But how did art get the way it did? And, more beguilingly, what is coming next

1 Why couldn't he decide which it was? Purpose or function? So much stands behind the "or" in this formulation, awaiting a liberation that was to come from a grammar that could not be foreseen. Purpose *in spite of* function. Purpose *despite* function. Purpose *at the depths of* function. Purpose *because of* function.

(to the right of Bourgeois Art in Burger's scheme)?

Burger's inability to imagine an answer to this question himself is symptomatic of the pessimistic fever caused by a "belief" in Historical Determinism. The question boils down to agency. Did thinkers like Burger consider there was any possibility of exerting one's own self in shaping the art of the future rather than merely being subservient to the slowly changing social conditions of the time? Burger and others (e.g. Adorno and Horkheimer) sourly ruminated upon the tendency of commercialist society to consume any rebellious act and make it mainstream simply by approving it, and thereby bringing it into the fold, rendering it non-revolutionary.[2] (As an example Burger pointed to Duchamp's readymades.)

Burger saw art as an institution that depended on its recognized place in society. Art could not change until society changed. So for Burger and others, an artist of "late capitalism" should not bother to reject his or her own autonomy because not only is such an attempt merely doomed to failure, but such a rejection is not even desirable in terms of realizing art's (apparently meager) emancipatory potential. For Burger, politically motivated artists in a late capitalist condition should simply revel in "that free space within which alternatives to what exists become conceivable." This amounts to putting messages into a bottle and wistfully tossing them into the utopian sea. Such a narrow prescription for political art reflected a lack of faith in the agency of cultural producers to change culture (or possibly a latent predilection for an art of which only experts could be the judge).

But why shouldn't artists and cultural producers have some significant influence over how what they make is made (production) and viewed (reception) and even over its purpose in society (function). Does it not simply take a critical mass of practitioners chiseling away at the old edifices to reshape the city? And why must all eyes be upon the future instead of the past? Couldn't the pendulum swing from its extremity in the individualist/autonomous zone back towards the collective? Can't art have a function beyond critique and utopian imagining, as it apparently did in Burger's scheme? Step one is involving art in the praxis of life. Step two is collectives. Step three is shunning "artistic expression" and the notion of the artist as rebel or outsider. Step four is granting the artist authority as an historian, sociologist, scientist, and/or psychologist.

We have not given this new form of art a name but to fill out Burger's table could look something like this:

Function: to produce empathy and ecological consciousness; to embody knowledge

Production: varied to the point of a collective

Reception: varied to the point of a collective

This picture of the art to come, waiting for its time in the sun, will ultimately be liberating and productive. Burger and his kind's self-inflicted pessimism belongs where it is now, on its pedestal in the Museum of Capitalism.

2 But revolutionary potential in this vein could be summarized by the simple phrase "you are what you eat."

WHAT DO WE DO WHEN WE'RE STUCK IN THIS KIND OF LOOP, THIS FEEDBACK LOOP? WE DO ONE THING; WE GO BACK TO THE BEGINNING. THE MUSEUM IS ONE OF THE PRIME SITES OF REVOLUTION. IN FACT, IT SEEMS ALMOST AS IF YOU CANNOT HAVE A REVOLUTION IF YOU DON'T STORM A MUSEUM. SO IT SEEMS … WE MAY HAVE TO GO BACK … AND STORM THE MUSEUM AGAIN.

HITO STEYERL

HERO OF CAPITALISM
DONALD TRUMP
1946 –
AMERICAN BUSINESS MAGNATE

"The point is that you can't be too greedy."

Riiko Sakkinen, *Heroes of Capitalism* series, 2016.

Kyle Henderson, *Circle*, 2016.

THERE IS ONLY ONE WAY TO ESCAPE THE ALIENATION OF PRESENT DAY SOCIETY: TO RETREAT AHEAD OF IT.

ROLAND BARTHES

Untitled mousetrap design from early twentieth-century US catalog.

THE WORLD ALREADY POSSESSES THE DREAM OF A TIME WHOSE CONSCIOUSNESS IT MUST NOW POSSESS IN ORDER TO ACTUALLY LIVE IT.

GUY DEBORD

William Philips, MONIAC machine, 1949 (artist's rendering).

Calum Storrie, *Between the Archive and the Street*, 2017.

The Monetary National Income Analogue Computer, commonly referred to as the MONIAC, is a hydraulic computer developed by William Phillips in 1949 while he was a student at the London School of Economics.

Prior to becoming an economist, Phillips studied electrical engineering before serving as a member of the Royal Air Force. During World War II he was held as a prisoner by the Japanese in what was known at the time as the Dutch East Indies. In spite of the conditions of the prisoner camp, he was reportedly able to put his engineering skills to use, constructing a miniature radio receiver hidden inside a clog and fashioning a system to boil water for hot drinks.

It was with this same spirit that Phillips built his first machine at a cost of around £400 using many scavenged parts. A second-hand clock was repurposed into an electric motor, and materials discarded by the Royal Air Force—including windshield wipers from a Lancaster bomber—were transformed into a working prototype.

Unlike other early computing machines of the time, the MONIAC was built according to analog principles. Although used primarily as a teaching tool, the machine was designed with the intention of modeling economic futures based on hypothetical economic policies. The water tanks of the MONIAC represent various sectors of a national economy: household, business, government, import, and export. Programmable equations are solved as water is pumped around the machine measuring income, spending, and gross domestic product.

"Let u be the production flow, v the consumption flow, w the stocks and p the price, all measured, for simplicity, from a base at which the system is in equilibrium," Phillips explained. In other words, income equals household expenditure plus business investment plus government expenditure plus export sales, less purchase of imports.

Around a dozen MONIAC machines were built and used at a handful of universities, the Ford Motor Company, and the Central Bank of Guatemala. In 1952, in the same issue of *Fortune* that coined the word "groupthink," the MONIAC was described as "economics in thirty fascinating minutes."

The machine was itself a prediction of a future in which computer modeling would become a ubiquitous tool for—before becoming essentially synonymous with—economic policy makers and financial institutions around the world.

THE DREAM OF GOING TO ANOTHER WORLD IS JUST THAT: A DREAM, AND PROBABLY ALSO A DEEP SIN. BUT TO SEIZE, OR SEIZE AGAIN, THIS WORLD, THIS SAME, ONE AND ONLY WORLD, TO GRASP IT OTHERWISE, THAT IS NOT A DREAM, THAT IS A NECESSITY.

BRUNO LATOUR

Standardized keys made of metal and used to unlock standard series handcuffs.

MUSEUM OF CAPITALISM: AN IMAGINAL INTERVENTION

CHIARA BOTTICI

In the beginning was the image. The image is primordial, given with psyche itself. What is our psyche if not first, and foremost, a stream of images? A stream of visions, perceptions, acoustic landscapes, tactile images, dreams— in sum: an imaginal stream of (re) presentations, that is, of representations that are also presences in themselves.

Well before being rational or social animals, humans are imaginal animals. Images are what mediates our being in the world: without images there would be no world for us nor any subject for the world. As such, images are not simply (re)presentations, that is, something that makes present what is actually absent, and thus, by definition the symptom of a lack, the sign of something that is not there. They are not an absence, but, first and foremost, they are a presence: they are the world that comes to us as an uninterrupted and indefatigable stream.

Yet, it is a stream that has long since been colonized by capitalism, with its formidable mechanism for the production of empty desire, always incapable of fulfilling itself. What is capital itself, if not first and foremost, a powerful engine for the production of images as lack? As a system predicated on endless profit, on the accumulation of capital in the fetishistic form of money and on the accumulation of goods in the fetishistic form of commodity, capitalism is a perversely utopian system.

Let us not forget that, according to the fortunate neologism of Thomas More's *Utopia*, the "good place" (*eu-to-pos*) is also, and inevitably, the "no place" (*ou-topos*). As such, capitalism is by definition utopian because it is predicated on the accumulation of a profit always-yet-to-come, an ever expanding mechanism of accumulation of wealth, on a desire that is from the beginning meant to never be satisfied.

And when the accumulation of goods has saturated the production process and capitalism faces one of its recurrent crises, with the subsequent fall of the rate of profit, capitalism has to become even more creative: selling services instead of goods, because there is a limit to the number of washing machines you can possess but there is no limit to the services that you may desire if they simply manage to capture your imagination. Hence the constant need not only

for soliciting our capacity to produce images in the moment of consumption, but for the systematic use of imagination in the production process itself.

Can there still be a place for subversive imagination in a world where imagination has been enlisted to serve the production machine? Can there be imagination, understood as the faculty to begin something new, in a world that is so full of new products and services that have to be sold "just in time"? How can we make sure that imagination remains a capacity to produce images that we possess instead of dissolving into the homologated imaginary that possesses us? How can one get out of the society of the spectacle if it is true that capital itself has reached such a degree of abstraction that it has become global?

If it is true that nobody can get completely outside of the society of the spectacle, outside of a society constructed of empty images, it is equally true that we can fight the evil with the evil itself: images with images, utopias with utopias, like in homeopathic therapy where the very poisonous substance is used to cure the evil it has provoked.

Hence the importance of the imaginal intervention operated by a museum of capitalism: to subvert the spectacle of capitalism by enacting a counter-spectacle, taking small doses of the evil and using them against themselves: images against images, commodities against commodities. In sum: re-appropriate the utopian spirit of capitalism by giving it a past.

Maybe we cannot jump outside of capitalism with a shrug of the shoulder. But it may be extremely beneficial to remind ourselves that we could. Capitalism is a historical form which has appeared at a specific point in time and there is no reason to suppose it will continue indefinitely. A museum of capitalism reminds us of that possibility: to all those who say that it is utopian to think that another world is possible, we can respond that another world has already begun.

MUSEUMS AND CAPITALISM

T. J. DEMOS

A *Museum of Capitalism*—how is it that such a thing did not appear sooner? Of course the question itself has been much discussed; indeed a cursory internet search for "museum of capitalism" yields more than a quarter of a million pages. But there is still no defining example or model, leaving the question unresolved.

Perhaps it's because we're living at a time when museums are already chock-full of capital. No doubt that is what art museums commonly represent already today, and maybe that's what they've fundamentally represented—at least in the West—over the last few hundred years. Isn't every museum today a museum of capitalism, in a world where capitalism has become global? Indeed capital suffuses all presence with its very being, including even forms of resistance. Undoubtedly we're so immersed in this world of capitalism's museums that we don't often recognize it. Maybe it's because the very term is unsavory to many, speaks of Marxist critique and revolution, or names a phenomenon that is so complex that it forces the term itself into the unsayable (capitalism is surely variegated, differentiated historically and regionally, and is admittedly a thoroughly nuanced and evolving politico-economic, technological, and socio-cultural evolving complex).[1] Yet isn't it then all the more crucial to insist upon speaking about it, especially at

a time when it's reached an unprecedented degree of universality?

Think of all the museums—such as MoMA in New York, San Francisco's MoMA, LA's MoCA, and so many others—with their galleries and wings bearing the names of wealthy donors and their families, the objects that were gifts of millionaire philanthropists, the collections on exhibition that are the collections of still more wealthy donors. Consider too the skyrocketing art market, where artworks sell for millions of dollars, which informs the reverence with which such objects are treated in the well-guarded temples of their exhibition. Those places, however, are not the open and inclusive sacred places of worship as with the world's great religions; instead they are the profit-seeking global tourist destinations with exorbitant ticketed entrance policies that reserve museums as enclaves of the well resourced and educated, the consumers with enough leisure time, where the enjoyment of art has become a distinction of class privilege.

While struggling artists, writers, critics, and educators attempt to raise the discourse and contribute to a culture that views art's intrinsic value as a form of experimental creativity, something that can be shared and contributes to our civic society broadly and freely, something that can offer profound reflections on our

1 For two important approaches to the recent and contemporary character of global capitalism that take into account both its regional differentiation and its hegemonic continuities, see Naomi Klein, *The Shock Doctrine: The Rise of Disaster Capitalism* (London: Penguin, 2007) and David Harvey, *A Brief History of Neoliberalism* (Oxford: Oxford University Press, 2005).

world-historical condition, and even something that can radically challenge the presumptions of how our world is organized, museums have become places that often appear diametrically opposed to those ambitions.

This is nothing new, of course, even though its extremes have intensified, and it has inspired decades of avant-garde activities seeking to challenge its conditions. For instance, the Futurists desired to tear down museums that they saw as annihilating the living vitality of culture; along similar lines, the Frankfurt School critically compared the museum to a mausoleum; the Situationists attacked "the spectacle" of "capital accumulated to the point where it becomes an image," along with the spectacle of its accumulation in museums; and conceptual artists developed the practice of "institutional critique" in order to analyze the economic functions of museums and their relation to class and politics. Consider Andrea Fraser's stunning recent examination of art's patronage structure in our era of grotesque economic inequality, where wealthy patrons not only support collectible culture to be stored in vaults as modes of financial speculation, but also frequently support neo-conservative politics and policies that seek to defund public institutions of social welfare, pensions, education, and healthcare, subjecting all to the inequality-producing injustices of the so-called free market, and of course placing themselves in the position of accumulating even more wealth.[2]

Welcome to the museum in the age of Trumpism, a political formation led by the billionaire class—coming at a time when, as reported recently in Oxfam, the eight richest people on Earth own as much wealth as the bottom half of the human population, approximately 3.6 billion people.

No doubt it's crucial to keep the discussion of a Museum of Capitalism alive in such times as these, and even to realize it as an explicit artistic project and critical political act, for the precise reason to raise awareness of these conditions. If Adorno was correct, in his 1953 essay "Valery Proust Museum," in supposing that the museum functions as a mausoleum, insofar as it exhibits the cultural remains of the past—"Museums are like the family sepulchers of works of art. They testify to the neutralization of culture," he wrote—then perhaps the Museum of Capitalism can take on a similar role, but now as a performative act.[3] Even though all museums operate in the determinative milieu of the reigning economic order, making all of this explicit carries great political potential in rendering the situation strange, tenuous, grotesque, and opposable. Perhaps in doing so it will reveal too the morbid symptoms of capitalism's terminal condition, as an economic arrangement operating according to the insufferable logic of extreme neoliberalism transformed into post-liberal authoritarian rule whose obscene levels of inequality necessitate the counter-insurgency enforcement of militarized police and secured borders. Perhaps what we're seeing in this capitalist museum initiative is the recognition of the last gasp of a politico-economic arrangement that is set on a suicidal course in destroying its own conditions of livability, driven by the logic of putting everything—water, air, human and nonhuman life, entire ecosystems, and critical habitats—up for sale.

In his book *Nihil Unbound: Enlightenment and Extinction*, the philosopher Ray Brassier develops a train of thought within the formation of a non-anthropocentric speculative realism, and provocatively suggests placing bookends around an epoch of human history—Enlightenment modernity—measured in hundreds of years that now may be coming to an end.[4] It may be we're living through that very end in the present. Does the Museum of Capitalism not announce this conclusion? If so, then we need it more than ever, precisely in order to bring an outside to capitalism into being.

2 See Andrea Fraser, "From the Critique of Institutions to the Institution of Critique," *Artforum* (September 2005) and Andrea Fraser, "L' C'est Moi," *Texte zur Kunst* (August 2011), 114–27.

3 "Museums are like the family sepulchers of works of art. They testify to the neutralization of culture." From Adorno's 1953 essay "Valery Proust Museum."

4 Ray Brassier, *Nihil Unbound: Enlightenment and Extinction* (London: Palgrave Macmillan, 2007).

A NONLINEAR JUSTICE

IAN ALAN PAUL

When we imagine ourselves inhabiting a particular time, this more often than not entails seeing ourselves located somewhere discrete, inhabiting one position alone. From this perspective, we understand the passage of time as being a journey through an endless series of these positions, proceeding from one point to the next on a line. This popular understanding of time is defined by being both singular and linear, like a railroad track laid out in front of and behind us that we are stuck riding atop of.

This way of thinking about time feels quite natural and intuitive because much of our time is already structured precisely in this way, whether it be when we clock in and out at work, or try to catch the right bus in the early morning, or when we time a run around a track. This form of linear time is the time of calculation and planning, of measurement and predictability. It's an understanding of time that allows us to set up elaborate conditions in the present to produce desired future outcomes, or in other words to construct knowable and reliable relationships between what we call the past, the present, and the future. So when we calculate the trajectory of a rifle before it's fired, we're unsurprised when the bullet finds its target, just as when we calculate the speed of our car, we're unsurprised when we arrive on time. Understanding time as linear assumes a world where things have known causes and consequences.

While this linear conception of time works very well towards particular causal ends, it also very quickly falls apart in substantial ways when we press just a little bit further towards that which resists being so easily calculated or planned, measured or predicted. For example, while most of you reading this will have had some experience with falling in love, I imagine few would confidently say that it could have been planned or entirely predicted in advance. Similarly, memories of the past more often than not closely resemble dense clouds or clusters than they do points that neatly follow one another in a clear succession of events. Ultimately, the linear conception of time most clearly breaks down when we set out to produce futures that are fundamentally different than the present we find ourselves within, particularly when we think in terms of justice.

Justice is a fascinating and ultimately dangerous concept because of the way it radically upends our normative relationship to time. In order to understand why this is the case, we first have to grasp what justice actually implies and entails. To call for justice, as people so often rightfully do, is also necessarily to explicitly point out the presence of some form of injustice in the present. The future arrival of the justice being called for will, in theory, correct the present injustice, and yet suddenly we find ourselves with an interesting dilemma. On the one hand, we can identify the need for a future which is more perfect

than the present we currently inhabit. And, on the other, when we acknowledge our place in an imperfect present we also acknowledge that our struggle for justice will be conditioned and in some sense compromised by this imperfection. This dynamic places us quite beyond the limits of calculability or predictability, because any calculation or prediction is already in some sense sabotaged in advance by the imperfect present it takes place within.

And so, when we desire something like justice we also find ourselves desiring a different kind of temporality as well, one which isn't linear or predictable but has an entirely different order to it. What would it mean to think of time in a fundamentally different way, to see ourselves as being located not just in the present but in some sense also exceeding it?

Justice understood in this way is a nonlinear process, which is another way of saying that it doesn't proceed or progress in a knowable or predictable fashion. As such, to engage in a struggle for justice is to knowingly fight for that which we in some way cannot know in advance, in perpetuity. Justice always remains speculative, ineradicably requiring forms of imagination that have fundamentally different relationships to time. In the end, we may actually find ourselves searching for ways to make the present itself multiple, to insist upon the possibility of the past and the future existing not in front of or behind the present along a historical line but rather alongside or perhaps even within it. This would require a willingness to draw together diverse and dispersed histories and futurities in the interest of constellating together the possibility of new ones.

This is what makes the demand of justice such a profound one. It asks that we see multiple pasts and futures inflecting on one another, and that we understand how pasts can be called to act anew in the present to set new kinds of future into motion. Justice can

be a way of thinking about that which will have to come to be, without having to decisively declare its relationship to what already is. This ability to see the world simultaneously as it is and as it can be is not a trivial affair, but is a struggle in itself, and may require not only a desire to make the world different but also a willingness to substantially transform ourselves in differential relation to those worlds that cannot yet exist.

Struggles against injustice are without known ends because they, by their very nature, don't proceed as expected. Instead, these struggles may be for a justice that remains perpetually in the future, a form of justice that can only ever be grasped, even if only partially and fleetingly, in the struggles that emerge from it, processually calling into existence histories and futurities that radically unsettle what is predictable about the present. Justice asks not what the past and future are, but rather what they could potentially and unexpectedly become anew.

AN AGONISTIC CONCEPTION OF THE MUSEUM

CHANTAL MOUFFE

As I have argued in *Agonistics: Thinking the World Politically,* the hegemonic approach is particularly fruitful for apprehending the relations between art and politics.[1] By bringing to the fore the discursive character of the social and the multiplicity of discursive practices through which "our world" is constructed, we highlight the fact that the construction of hegemony is not limited to the traditional political institutions—it also takes place in the multiplicity of places of what is usually called "civil society." This is where, as Antonio Gramsci has shown, a particular conception of the world is established and a specific understanding of reality is defined, what he refers to as the "common sense," providing the terrain in which specific forms of subjectivity are constructed. And Gramsci indicated that the domain of culture plays a crucial role because it is one of the terrains where the "common sense" is built and subjectivities are constructed.

When we envisage the role of museums within such a framework we realize how museums and art institutions could be part of the counter-hegemonic struggle. Far from being seen as conservative institutions, impervious to change and dedicated to the maintenance and reproduction of the existing hegemony, they can indeed contribute to undermining the imaginary environment of the consumer society. To be sure, the history of the museum has been linked since its beginning to the construction of bourgeois hegemony, but this function can be altered. As Wittgenstein has taught us, signification is always dependent on context and it is use which determines meaning. This is also true for institutions, and we should discard the essentialist idea that some institutions are destined to fulfill one immutable function. In fact we have already witnessed how, following the neoliberal trend, many museums have abandoned their original function of educating citizens into the dominant culture only to be reduced to sites of entertainment for a public of consumers. The main objective of those "postmodern" museums is to make money through blockbuster exhibitions and the sale of a manifold of products to tourists. The type of "participation" that they promote is based on consumerism and they are actively contributing to the commercialization and depoliticization of the cultural field.

However this neoliberal turn is not the only possible form of evolution, and

1 Chantal Mouffe, *Agonistics: Thinking the World Politically* (New York and London: Verso, 2013).

another one can be envisaged leading in a progressive direction. There might have been a time when it made sense to abandon the museums to open new avenues for artistic practices. But in the present conditions, with the art world almost totally colonized by the markets, museums could be seen as privileged places for escaping from the dominance of the market. Boris Groys, for instance, has argued that the museum, which has been stripped of its normative role, could provide a privileged place for art works to be presented in a context that allows them to be distinguished from commercial products.[2] Visualized in such a way, the museum could offer a place for resisting the effects of the growing commercialization of art and for countering the dictatorship of the global media market.

Following the hegemonic perspective, we could also rethink the function of the museum in a different way. If we accept that instead of celebrating the destruction of all institutions as a move towards liberation, the task for radical politics is to engage with them, developing their progressive potential, we can visualize the possibility of converting the museums into sites of opposition to neoliberal hegemony and of transforming them into agonistic public spaces where this hegemony is openly contested. The purpose of this agonistic model of the museum is to bring about a democratic culture that will empower citizens by creating a public space capable of fostering a variety of practices to develop their critical capacities. As Manuel Borja Villel has argued, this requires establishing a dynamic relation with the territory where the museum is located and its particular memory, grasping the power relations through which this territory is structured.[3] This is, according to him, the precondition for creating a relation with the public that will activate their critical capacities, providing citizens with the tools that will allow them to exercise those capacities.

To envisage the museum in an agonistic way, it is necessary to acknowledge that what is at stake in cultural institutions is a hegemonic struggle about the definition of the common sense and the construction of the social imaginary. Museums and public institutions are places where a struggle takes place between conflicting representations of history and the way society should be organized. This conflictual dimension needs to be recognized and activated. Transformed into agonistic public spaces, museums would facilitate the expression of dissent, helping people to better understand the contradictions of the world in which they are living and allowing them to see things from different points of view. By providing people with a different kind of experience than the one they find in their role as consumers, and making them aware that aesthetic experience cannot be reduced to the mere act of consuming, museums and cultural institutions can also become spaces of resistance to the process of commodification of culture brought about by the development of cultural industries. Museums and cultural institutions could in that way play a decisive role in the struggle for the radicalization of democracy.

2 Boris Groys, "The Logic of Aesthetic Rights," in *Art Power*, MIT Press (Cambridge, MA: MIT Press, 2008).

3 See for instance, Marcelo Exposito, *Conversacion con Manuel Borja-Villel* (Madrid: Turpial, 2015).

IT IS MY GUIDING CONFESSION THAT I BELIEVE THE GREATEST ERROR IN ECONOMICS IS IN SEEING THE ECONOMY AS A STABLE, IMMUTABLE STRUCTURE.

JOHN KENNETH GALBRAITH

Evan Desmond Yee, *iPhossil*, 2011.

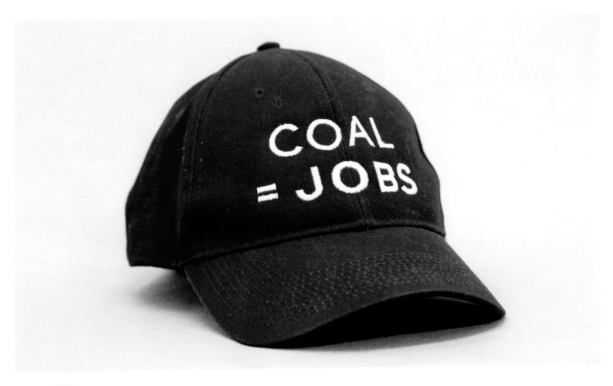

COAL=JOBS hat.

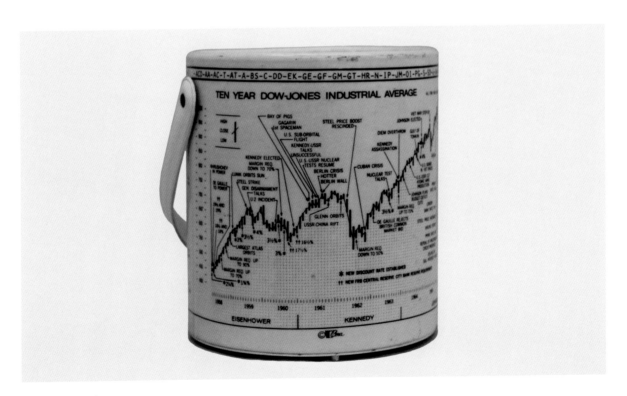

Dow Jones ice bucket.

Parchman Penitentiary coin.

Parchman Penitentiary coin.

Fast food restaurant playset.

Fast food restaurant playset.

Rear wheel of trick tricycle.

Trick tricycle.

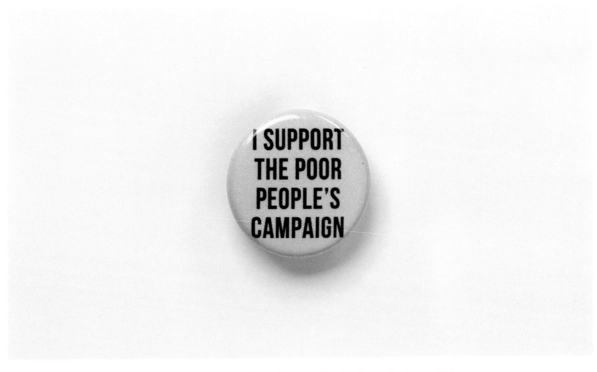

Kate Haug, *50% Accurate Copy of Poor People's Campaign Button Found on Ebay Too Expensive to Buy*, 2016.

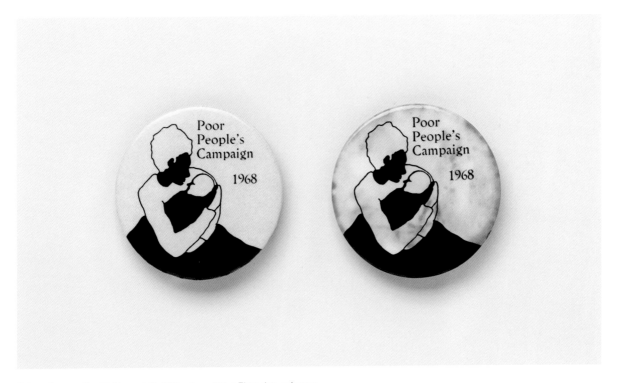

Artist unknown, *One Mother and Child Purchased from Ebay*, date unknown.

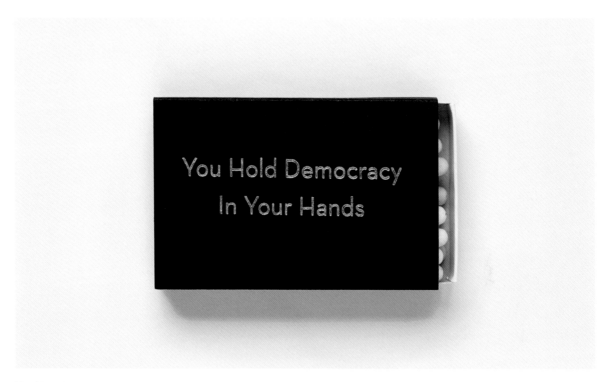

Kate Haug, *Matches*, 2016.

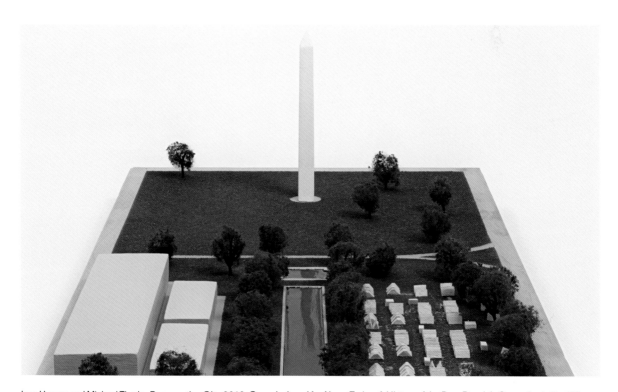

Ivan Uranga and Michael Thede, *Resurrection City*, 2016. Commissioned for *News Today: A History of the Poor People's Campaign in Real Time*.

Terri Warpinski, untitled, no date.

Jennifer Dalton, *Reckoning*, 2012.

Center for Tactical Magic, *Universal Keys* (detail), 2017.

Christy Chow, *De-Stitching* (stills), 2014.

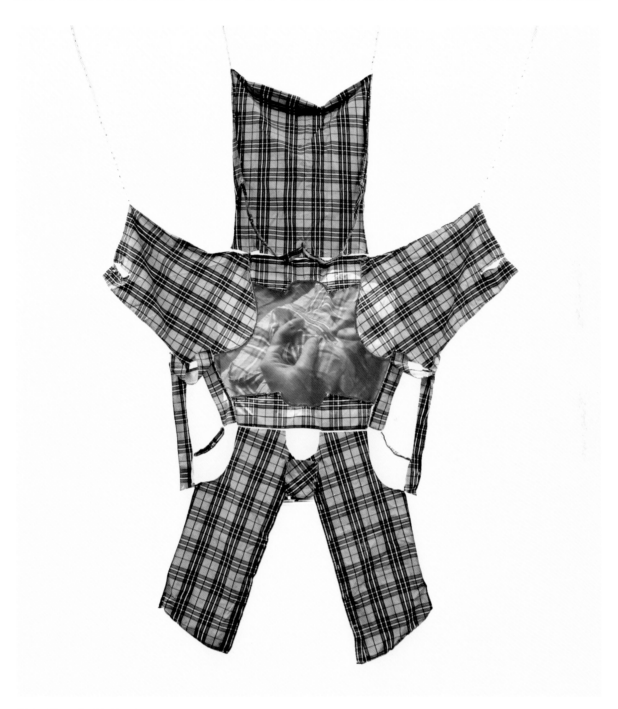

Christy Chow, *De-Stitching*, 2014.

Jesse Sugarmann, *We Build Excitement* (stills), 2013.

Dario Azzellini and Oliver Ressler, *Occupy, Resist, Produce* (still) 2014–15.

Curtis Talwst Santiago, *Frida's Entry into Iguala* (detail), 2015.

Jennifer Dalton, *Ask Not For Whom the Art is Intended*, 2014.

Jordan Bennett, *Artifact Bags*, 2013.

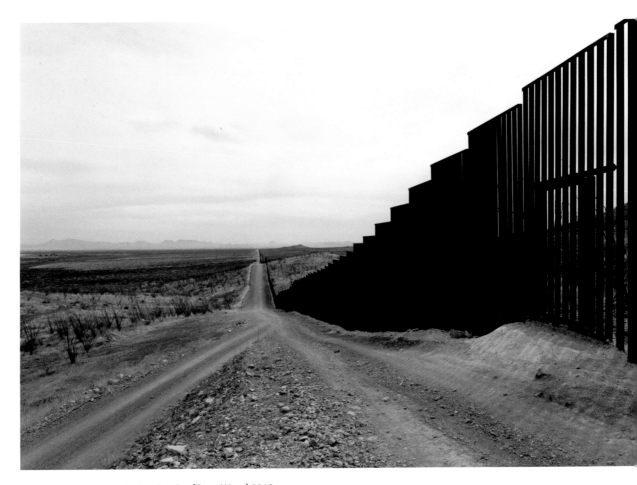

Terri Warpinski, *As Far as the Eye Can See [East of Naco]*, 2012.

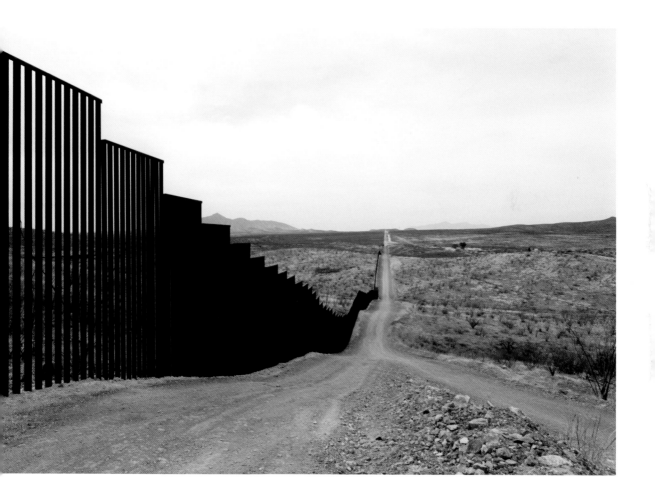

Curtis Talwst Santiago, *The Execution of Unarmed Blacks*, 2014.

Dread Scott, *Poll Dance*, 2010.

Mark Curran, *Matthew, Banker (negotiation 2 years)*, 2013.

Mark Curran, *Bethlehem, Trader (negotiation 1.5 years)*, 2012.

Kelly Jazvac, *Plastiglomerate (various)*, 2016.

Dentures of George Washington.

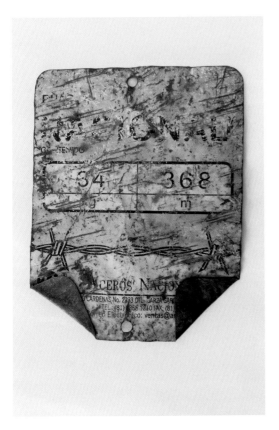

Terri Warpinski, *Border Marker*, 2016.

Susie Williams, *Reconstituted Operation Bread Basket Poster*, 2016. Commissioned for *News Today: A History of the Poor People's Campaign in Real Time.*

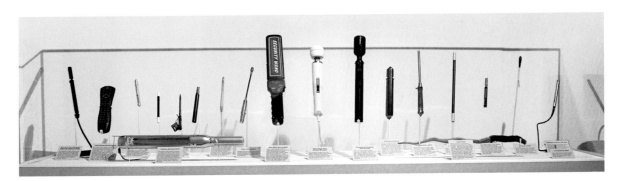

Center for Tactical Magic, *Wands*, 2008.

Steven Cottingham, *Unititled*, 2016.

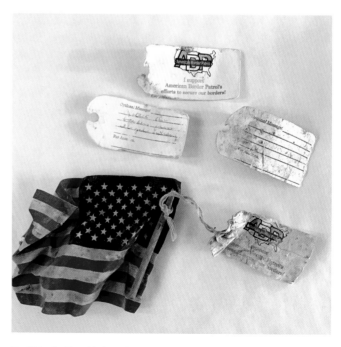

Terri Warpinski, untitled, no date.

Evan Desmond Yee, *Displays*, 2015.

Jennifer Dalton, *Your Name Here*, 2014.

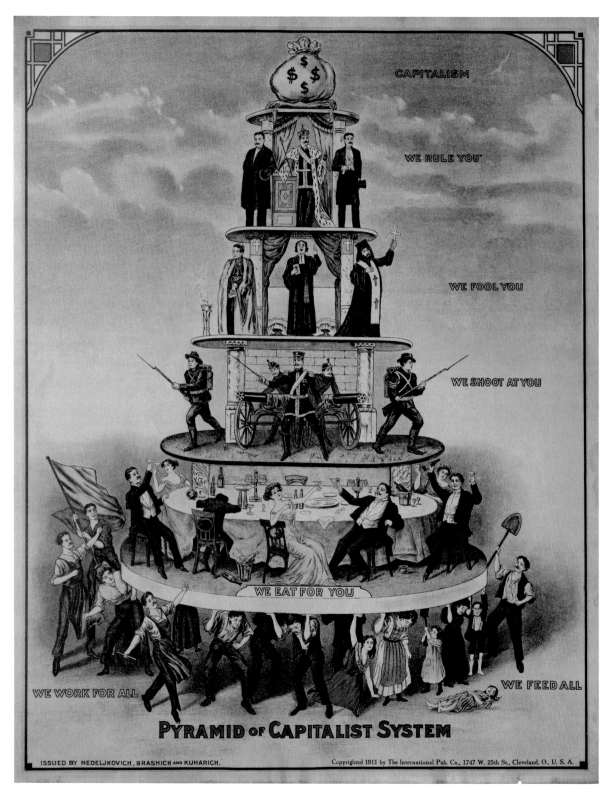

Industrial Workers of the World advertisement attributed to Nedeljkovich, Brashich & Kuharich, published in *Industrial Worker*, 1911.

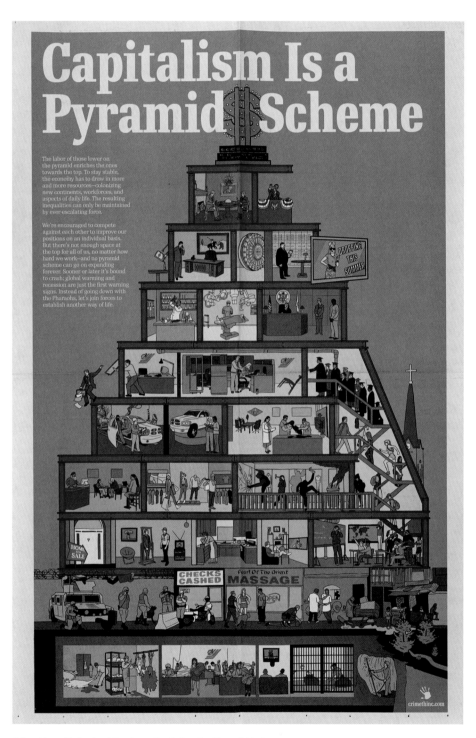

Crimethinc with Packard Jennings, *Capitalism is a Pyramid Scheme*, 2011.

Amy Malbeuf, *Jimmie Durham 1974* (detail), 2014.

Michelle de la Vega, *Succession*, 2016.

Patricia Reed, *Pan-National Flag*, 2009.

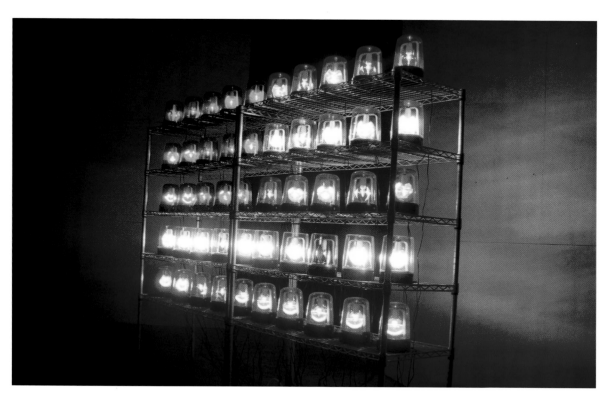

Blake Fall-Conroy, *Police Flag*, 2009.

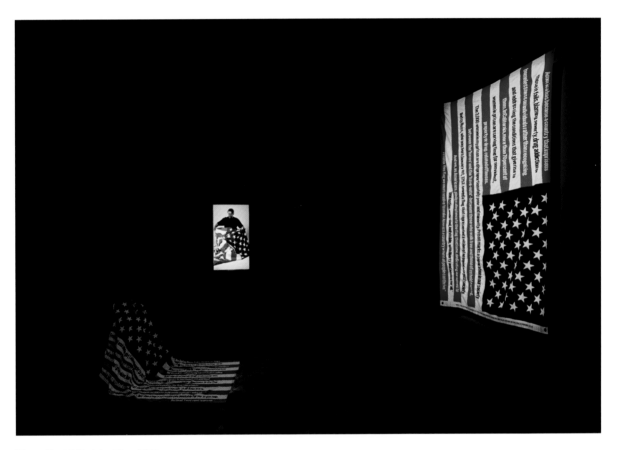

Sharon Daniel, *Undoing Time*, 2016.

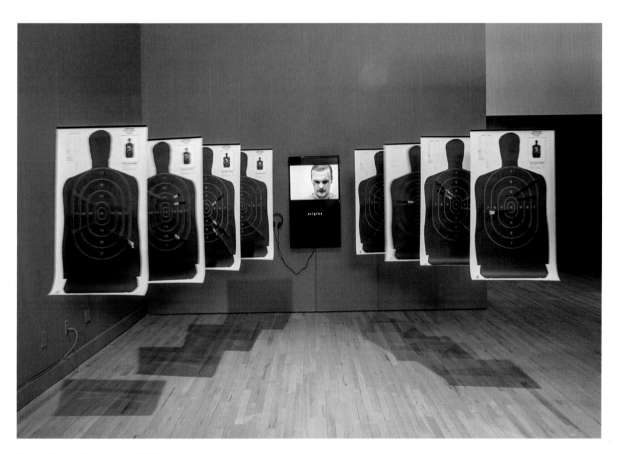

Sharon Daniel, *Undoing Time*, 2016.

Center for Genomic Gastronomy, *Rare Endophyte Collectors Club*, 2016.

Sayler/Morris, *Money Store*, 2016 (from *Water Gold Soil: American River* series).

Sayler/Morris, *Control Room*, 2016 (from *Water Gold Soil: American River* series).

Winter Count Collective (Cannupa Hanska Luger/Dylan Mclaughlin/Ginger Dunnill/Nicholas Galanin/Merritt Johnson), *WE ARE IN CRISIS*, 2016.

Chip Lord, *To & From LAX* (stills), 2010–15.

Erika Osborne, *The Chasm of Bingham*, 2012.

Jenny Odell, *39 Landfills*, 2011.

Temporary Services, *Abandoned Signs (Midwest)*, 2015–17.

Alex Klose, *The Logistical Transcendental*, 2006–09/2017.

Ben Bigelow, *Ellipsis* (stills), 2012.

Jenny Odell, *Transportation Landscape* (detail), 2014.

Tim Portlock, *Memorial*, 2015.

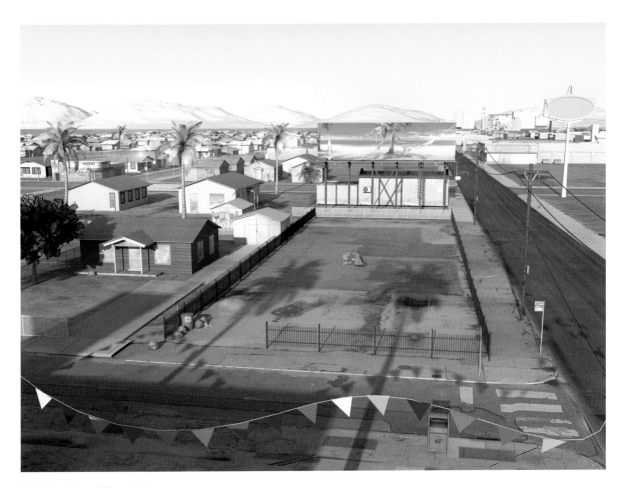

Tim Portlock, *Beach View*, 2015.

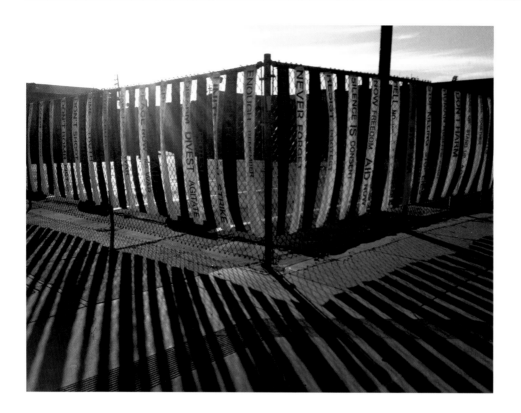

Taraneh Hemami, *People Power*, 2015.

THE END OF CAPITALISM

SASHA LILLEY

Capitalism's shelf life expired, it could be argued, in the early twentieth century. After that point, humanity no longer struggled with scarcity, but abundance—an abundance that was unevenly distributed between the Global North and South, and between the downtrodden and the wealthy. Capitalism, it need hardly be stated, had long outlasted its sell-by date.

Through much of the twentieth century, capitalism's end was easily imagined and even expected, not just by landless rebels and urban insurrectionists, but establishment figures like John Maynard Keynes and Joseph Schumpeter, who briefly served as Austria's Minister of Finance. The past forty years have been different. It's been an age of overt catastrophe—extreme environmental devastation, imperial interventions, and class war from above. Yet, no matter how nakedly devastating capitalism has become, the idea that it could come to an end has been harder and harder to contemplate. Not surprisingly, the end of capitalism—when it has been contemplated—has been imagined in apocalyptic terms. And, significantly, in this period, its demise is often conceived not as the result of collective action, but as some type of system collapse.[1]

Capitalism's end, broadly speaking, has been imagined during the neoliberal era in one of two ways: either as the result of the collapse of nature or the breakdown of the economy. In what follows, I examine those two visions in turn and then consider their limits and commonalities.

§

Without a doubt, the catastrophe facing the natural world—which includes us— is real. Many have come to recognize, in the wake of the extinctions of untold thousands of species and the collapse of myriad ecosystems worldwide, that much of the natural world as we've known it cannot survive under capitalism. There are also those who think that capitalism's need for endless growth can't outlive the limits of nature's finite resources. The end of capitalism—sometimes framed as the end of civilization—is in the cards when the system reaches these limits and, rather than just contracting, collapses.

Capitalism's death from nature's finitude can be found on both the Right and the Left, from the Club of Rome's famous *Limits to Growth*, predicting the collapse of social systems by the end of the twenty-first century, to the leading intellectual of the Occupy movement: "There is very good reason to believe that, in a generation or so, capitalism itself will no longer exist— most obviously, as ecologists keep reminding us, because it's impossible to maintain an engine of perpetual growth forever on a finite planet."[2] Capitalism needs endless compound growth to thrive, whereas natural resources are limited and becoming ever scarcer. What happens when capitalism has nothing left to exploit?

1 In the late nineteenth and twentieth centuries, the left envisioned the end of capitalism in several different ways, often connected to the strength—or lack there of—of mass radical forces at the time. I've written elsewhere about the two sides of left catastrophism historically—determinism on the once side and voluntarism on the other—but focus here on the former. See Lilley, et al, *Catastrophism: The Apocalyptic Politics of Collapse and Rebirth* (Oakland, CA: PM Press, 2012).

2 David Graeber, *Hope in Common* (The Anarchist Library, 2008), p 1. I revisit Graeber later in the essay, as he has much light to shed on the state of collective action under neoliberalism.

Nowhere are these limitations more clear, the argument frequently goes, than with capitalism's dependence on petroleum. Industrial capitalism flourished because of petroleum and now faces its demise as easily accessible oil resources become scarcer—a notion known as peak oil. Derrick Jensen, a writer with a wide audience among left environmentalists, and his now defunct organization Deep Green Resistance, made the case that peak oil would lead to the collapse of industrial capitalism.[3] Large-scale manufacturing and agriculture would grind to a halt, they wrote, governments would topple, authoritarian regimes would seize power and use mind control on their populations. Against this dystopian backdrop, radicals would have a choice either to sit back and watch, or to hasten the collapse, while organizing mutual aid through small autonomous communities. In 2011, they forecast the collapse a mere four years later. (I should note here that putting a date on the day of reckoning is never a good idea.)

As peak oil illustrates, there are more than a few drawbacks to the idea that capitalism will collapse due to absolute natural limits. Rather than breaking down because of petroleum scarcity, the United States now rivals Saudi Arabia and Russia as one of the biggest oil producers in the world. That's because capitalists invested in technologies to find new sources of oil, in the face of diminishing resources (or even just high prices). In this case, it was extracting oil fracked from shale rock. While its success is never a forgone conclusion, the history of capitalism is replete with examples of limits being encountered and then sidestepped.

It could be countered that something has now changed, given the magnitude of the destruction of nature. Couldn't the mass scale of degradation of the environment, with ecological crisis piled upon ecological crisis, mean that we're in a different world from which capitalism won't find its way out? While I'm more than sympathetic to the idea that endless growth isn't possible, I think this conclusion may be too hopeful. Capital accumulation has always been highly geographically uneven—the malaise of the 2008 crisis of capitalism is centered in the Global North, not the Global South, for example—and has always been based on destruction as well as creation. Regions grow, while others collapse. The anarchist Buenaventura Durruti, in the midst of the Spanish Civil War, said, "We the workers have built this world and aren't afraid of ruins, because we can rebuild it." I'm afraid that's actually more descriptive of the capitalist class. They aren't afraid of the ruins, since war and the destruction of existing infrastructure is a very profitable business and regenerative to capitalism, as was seen in the reconstruction of Europe and parts of East Asia following World War II. Sadly, environmental catastrophes may not be impediments for profit-making, but fertile ground. Already, there are many capitalists who hope to profit from the most deleterious effects of global warming, such as mineral mining in the High Arctic and growing crops on previously frigid land in the former Soviet Union. The Israelis have even been manufacturing fake snow for the melting Alps. Opportunities abound for disaster capitalism.

§

The radical Left, going back at least to Marx, has a long history of expecting the collapse of capitalism out of the system's periodic economic crises. Marx himself moved away from that position, but many of his successors did not. Many on the Left initially greeted with glee the global crisis of the capitalist system, which began in 2007–08, thinking that the final moment was at hand. After the dust settled, it became clear that the crisis was not going to topple capitalism. In fact, the crisis—in line with the role crises have played in the history of capitalism—provided an enormous

3 Aric MacBay, Derrick Jensen, and Lierre Keith, *Deep Green Resistance: Strategy to Save the Planet* (New York: Seven Stories Press, 2011).

opportunity for further class war from above. Austerity has been the hallmark of our ostensibly post-crisis time.

Despite the profits extracted under the auspices of crisis, there are a multitude of left critics who argue that capitalism is suffering from a debilitating malady. German sociologist Wolfgang Streeck believes it's terminal. In fact, he argues, the collapse of capitalism is happening right now. Significantly, not only is the collapse happening without people in the streets building barricades or striking or occupying factories—it's taking place precisely because of the absence of these things. It's occurring because of the lack of mass collective action.

Capitalism, Streeck suggests, has won so resoundingly that it's paradoxically leading to its own defeat. He argues that mass political agency—the ability of people to come together to effect change—has been irredeemably destroyed by forty years of neoliberalism. And by destroying that mass agency, the system has doomed itself. That's because historically the Left—or the worker's movement or social movements—has saved capitalism from its most extreme tendencies, which might obliterate the basis, whether social or environmental, for the continuation of capitalism itself. The Left has forced the state to adopt environmental protections, such as those that would keep key natural resources from being irreversibly depleted, and to embrace social democracy, which in the past allowed for high levels of economic growth while ensuring that workers were productive, rather than exploited to the limits of human endurance. But capitalism is on its way out—even without those who could act together, and without a notion of what a future post-capitalist alternative might be. The trends of declining economic growth, increasing inequality, and financial instability are going to continue, with nothing to reverse the downward slide. While protest movements may arise as

the decay sets in, Streeck argues, they will remain localized, uncoordinated, and might add to the crisis. He has little faith in larger or more effective upsurges, writing: "disorganized capitalism is disorganizing not only itself but its opposition as well, depriving it of the capacity to defeat capitalism or to rescue it. For capitalism to end, then, it must provide for its own destruction— which, I would argue, is exactly what we are witnessing now."[4]

Streeck makes a convincing case for the disorder, and crisis of ideas, that confronts the capitalist class of the Global North in the wake of the 2008 financial crisis. Less convincing is his argument that capitalism as a whole is in its last throes. Many Marxists have claimed that global capitalism has been stagnating since the 1970s, but that assessment omits the massive growth of the economies of East Asia and other parts of the Global South. Even Streeck admits that his conclusions about a persistent downward trend of growth apply to Europe and North America, not Brazil, Russia, India, and China.

Even if Streeck is correct that, looking at the Global North, the economic future will remain bleak, it's not clear why that would lead to the end of capitalism. Particularly if you remove the threat of the disgruntled masses, who according to Streeck will only just add to the disorder, why should a more miserable society result in the end of capitalism? It's fairly easy to imagine other outcomes—partially because we've more than glimpsed them—in which capitalism remains entrenched under a more overtly authoritarian state.

§

What unites the visions of an end to capitalism based on ecological finitude with those predicated on the idea that the economy is terminally ill? In both cases, the system comes to an end because it hits insurmountable limits, not because it's brought down by human collective action. It's as if we're now in

4 Wolfgang Streeck, "How Will Capitalism End?" *New Left Review* (May–June 2014):87.

a world where there's no chance of changing anything through mass action.

But are we? Is mass collective change also in irreversible, terminal crisis? Has neoliberalism effectively and eternally limited our capacity to act collectively to oppose and bring an end of capitalism? Should we wait for the collapse as our last best hope?

The Left has historically regarded the working class as the group that would bury capitalism. That class, in particular, is now frequently seen as passive at best and reactionary at worst. Significantly, those views took hold, not following the imposition of neoliberalism in the late 1970s, but before it. In the 1960s, many radicals gave up on the working class, whom they saw as bought off by the system, and looked instead to Third World revolutionaries. Ironically, this shift overlapped with a period of upsurge of working class militancy, of hot autumns and winters of discontent. In 1970 alone, there were nearly 6,000 strikes in the US, involving three million workers. On several occasions the US state sent in the military (as when soldiers were ordered to quell a national wildcat strike by truckers, and then redeployed to face down anti-war protestors at Kent State). Women workers and workers of color, as well as those who were employed by the service sector, battled on the frontlines, but were frequently invisible to the Left. Radicals outside of these movements, often from middle class backgrounds, were myopic. They couldn't see past the conservatism of the union leadership—itself the result of unions purged of radicals during the McCarthy era—and recognize the rebellions from below, many of them wildcat. When organized—and unorganized—labor was confronted and then crushed by nascent neoliberalism, much of the rest of the Left didn't realize what was at stake.

Undoubtedly, neoliberalism has made radical mass action harder. But the story is complicated. It's not simply about people held in thrall to consumerism, "with collective goods, collective action and collective organization thoroughly out of fashion."[5] One of the central pillars of neoliberalism has been its all-out assault on organized resistance. Since the advent of neoliberalism, we've seen this time and again, from Reagan's sacking of striking air traffic controllers, to the Volcker Shock, in which the US Treasury deliberately raised interest rates to put malcontented proles out of work and back in their place, to Thatcher's militarized attack on the National Union of Mineworkers, up to the present.

The neoliberal era has not just been characterized by scattershot, local protests. It's been a time of repeated mass mobilizations. The challenge has been finding new forms of organizing that allow movements to be sustained. Yet even the Left forgets much of this history. During the neoliberal era, there have been a multitude of remarkable struggles. In 1982, over a million people gathered in New York City to protest nuclear weapons. That same decade ACT-UP forced state action against the AIDS pandemic, while tens of thousands organized to oppose American support for apartheid South Africa, and US intervention in Central America. People in cities all over the US came out en mass to oppose the First Gulf War in 1991. The following year there was civil unrest all over the country, and the National Guard was sent into Los Angeles, after the Rodney King verdict. In 1997, UPS workers struck and won a crucial victory. Two years later, Teamsters and turtles famously joined together to shut down the meeting of the World Trade Organization in Seattle. In 2003, perhaps the largest demonstrations in history took place around the world to oppose the pending US invasion of Iraq. In 2006, immigrant workers struck en masse—the largest general strike in US history. In just the last several years, Occupy exploded on the scene and spread to cities large and small. Over a hundred thousand

5 Ibid.

people occupied the Wisconsin State Capitol (an action initiated by precarious teaching assistants) to oppose anti-union legislation. Civil unrest broke out in Ferguson, after the police shooting of Michael Brown, and the US sent in the national guard. The residents of Baltimore similarly protested after Freddie Gray was killed in police custody. In the wake of these and other killings, Black Lives Matter proliferated around the country to confront racialized mass policing and brutality. Members of the Standing Rock Sioux Tribe, with support from over three hundred North American tribes and other activists, blocked the Dakota Access Pipeline. Mass protests greeted the presidency of Donald Trump, from his first days in office onward. And those are just some examples—and only from the United States.

As David Graeber has written, "Hopelessness isn't natural. It needs to be produced. If we really want to understand this situation, we have to begin by understanding that the last thirty years have seen the construction of a vast bureaucratic apparatus for the creation and maintenance of hopelessness, a kind of giant machine that is designed, first and foremost, to destroy any sense of possible alternative futures. At root is a veritable obsession on the part of the rulers of the world with ensuring that social movements cannot be seen to grow, to flourish, to propose alternatives; that those who challenge existing power arrangements can never, under any circumstances, be perceived to win."[6]

Such hopelessness even extends to the way we picture the end of capitalism. We've given up on ourselves and can't envision human collective action bringing capitalism down. Much of the time, we can't even envision what a post-capitalist society might look like, which adds to the problem. We're politically and intellectually enmeshed in a politics of despair. But that despair appears existential, when in fact, it's the result of political defeats.

Capitalism isn't eternal. There's every reason to believe it will come to an end. But, despite the serious impediments to social change in the neoliberal era, expecting capitalism to collapse under its own weight is misguided. It's a projection of our feelings of powerlessness onto the future, hoping that external limits of one sort or another will solve the problem for us. But we're not powerless. And the history of social movements is often one of repeatedly unrewarding organizing that one day, to everyone's surprise, bears fruit. Who would believe that years of labor organizing in Egypt would one day erupt in the Arab Spring? Who would imagine that yet another protest, this time in a park near Wall Street, would spark a fire that extended throughout the country and world? Did these bring down capitalism? Obviously not. But each attempt to organize, to take mass action seriously, provides lessons for building collectivity against the forces of fragmentation, for reminding us what might be, and in coming together, taking off the constraints reining in our visions of the future.

6 David Graeber, "Hope in Common," *Adbusters* 82 (March/April 2009).

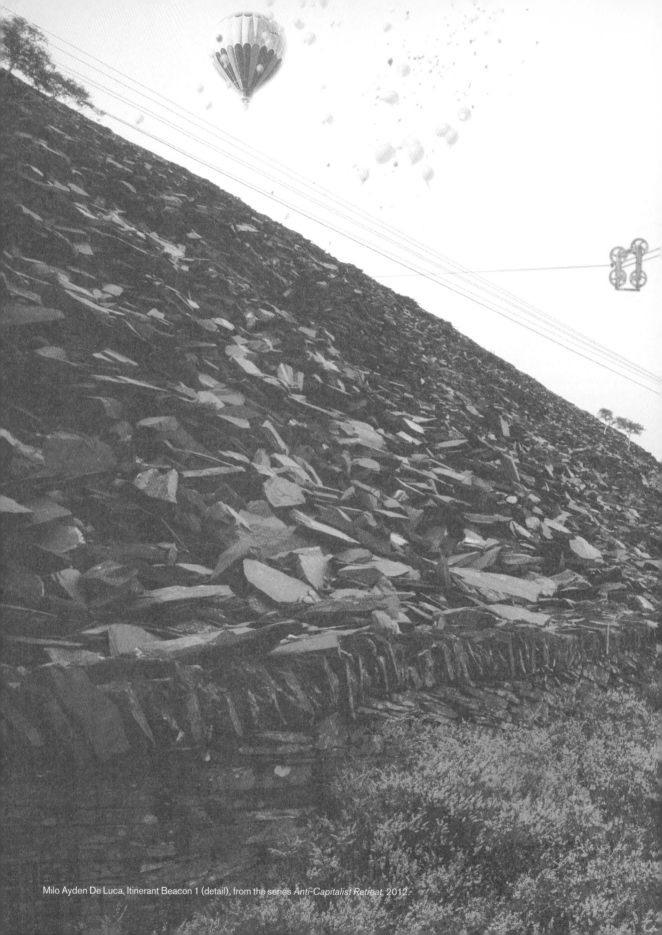

Milo Ayden De Luca, Itinerant Beacon 1 (detail), from the series *Anti-Capitalist Retreat*, 2012.

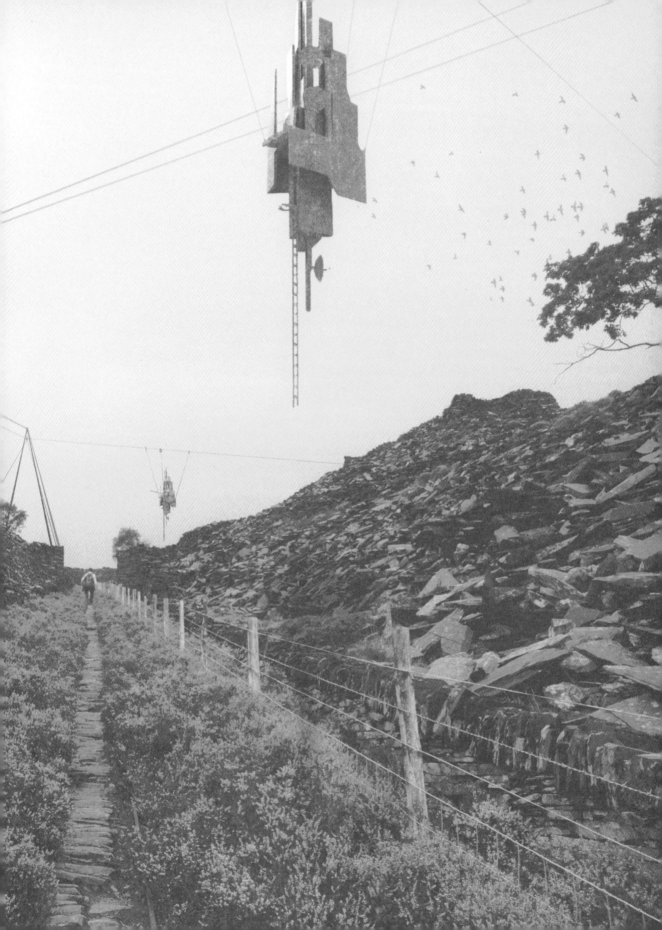

CAPITALISM AS AN ARTIFACT

MCKENZIE WARK

Is "capitalism" really an adequate term to describe the currently dominant mode of production? Is this still capitalism? Or is it something worse? Perhaps it is time to consign the term to the museum of concepts worn out by overuse, or by the slow transformation of their object into something else. Perhaps it became a habit to call whatever is out there capitalism, even though what is out there to be so called has been changing bit by bit, to the point where what is now called capitalism really bears only a partial resemblance to what was called capitalism in the past.

Without some notional sense of both origins but also potential endpoints, the concept of capitalism risks becoming a bit too totalizing and ahistorical. Either in the mode of critique or the mode of analysis, research will be drawn to what appears continuous in the object of study, and not notice things that point towards transformations into something else.

Capitalism does indeed seem to be back as an analytic object. In my own little world, the "cultural turn" treated too much interest in the mode of production as vulgar Marxism. So too did what one might call the "political turn." Now that Stuart Hall and Ernesto Laclau have passed away, let's not forget what was valuable in the cultural and political turns, of which they are avatars. But at the same time, it is worth pointing out

that both took the underlying economic form of capitalism to be more or less unchanged. What was interesting and new to them was at the cultural or political "level" of the social formation.

The renewed emphasis on "capitalism" as an object comes at a time when both of the possible historical grand narratives about its future have receded. It's hard to sustain much faith in bureaucratic socialist planned economies as any kind of alternative. Khrushchev did not bury us with "red plenty." Also in retreat are various "third way" narratives about how capitalism has passed over into some more sophisticated world where class struggle and ideology are dead.

And so, strikingly, the narrative imaginary that is most widely shared is that capitalism just goes on and on. As if it were eternal. Here people who imagine themselves leftists or even Marxists do the work of the Right for them, by insisting with striking emotional fervor that this just must be capitalism. The sheer refusal to think outside that category is the sign of ideology at work.

One sign of strain in "capitalism" as a concept is the frequent addition of modifiers. Periodization has become internal to the concept rather than external. And so we have: neoliberal capitalism, post-Fordist capitalism, communicative capitalism, biopolitical capitalism, cognitive capitalism, semio-capitalism,

not to mention the persistence of the charmingly named "late" capitalism. But is there not a certain failure of imagination in merely adding a qualifier to return strange new observable features of the social formation to the familiar ground of capitalism?

These modifier-capitalisms are failed concepts. They do not explain so much as explain away. They fail to do the key work of a concept, which is to defamiliarize, to make strange the seemingly self evident. It is in that spirit that, as a thought experiment, I have been trying to find signs that there might be some quite other mode of production nascent in the old capitalist one. What if what was emerging was not more capitalism, not even really a kind of capitalism, but something worse? Something with all of the worst features of capitalism: exploitation, inequality, instability, class polarization, ecological crisis, but also some things not well captured by the analytics or critique of "capitalism."

It might help to define the concept a bit more at this point. By "capitalism" I mean one thing in particular: a social formation with a ruling class which dominates by the ownership of the means of production. This is of course not the only way to define capitalism, but it is the sense in which I mean it here. My question then is: Could there be an emergent ruling class that does not dominate the social formation through the ownership of the means of production, but through some other means?

If one looks, for example, at Fortune 500 companies, it's striking how many don't really own much by way of the means of production in any traditional sense. That icon and relic of Fordism—the Ford Motor company—still owns the factories that make its products. But as became evident in 2008, Detroit was actually making a big slice of its profits not from making cars but from financial service.

Apple does not really make much of its own products. Neither does Microsoft. A lot of that is contracted out. These are companies that control the production cycle by controlling brands and intellectual property. The drug companies do make things, but it's a tiny fraction of their value.

What matters in most of these cases is owning the brand, the patents, and the copyrights, together with those vectors along which information is gathered, analyzed and made effective. The latter is the path pioneered by Google, whose chief asset is the capacity to gather and analyze data.

Take the biggest of the Fortune 500 companies, Walmart: is it really a company that dominates its sector because it owns more box stores? Or is it more to do with superior logistics? Walmart figured out how to manage distribution on a hitherto unimaginable scale by managing data. Likewise, Amazon cherry-picked certain kinds of product for which a logistics would work that did not need retail stores.

Perhaps what is going on is a kind of power that has less to do with owning the means of production and thereby controlling the value cycle, as in capitalism. Perhaps it is more about owning the means of mediation, which in turn controls the means of production and hence the value cycle. The actual production can be outsourced, and manufacturing firms will have to compete for the privilege of making products with someone else's intellectual property embedded in it, and sold under someone else's brand. There's no need to own the means of production at all.

In some cases, certain key parts of production may well be retained, or even acquired. Google is scooping up firms that actually make things in the fields of robotics and the "internet of things." But the vast extension of so-called intellectual property in the last half century, combined with ever more efficient ways of communicating and managing data, means that a tremendous amount of power can now reside in simply owning the means of mediation.

Why would this be something other than just more capitalism? Let's have a closer look at what happened to the means of production. Marx was writing in that great era where steam power transformed the forces of production. The worker no longer controlled the tool; the machine controlled the worker. Workers became interchangeable. The physical actions of the worker could be captured and quantified, and as Marx so grandly showed, the worker only received a fraction of the value of their labor.

Is that still how the forces of production work? For a lot of workers, yes. Other power sources have replaced steam, but the worker is still controlled by the machine, and the worker's labor is controlled and quantified by the machine. Estimates of the number of industrial workers in China vary, but it is at least eighty million. If anything, this is the great era of the industrial forces of production.

Industrialization shifted power away from a landowning class who collected rents on agricultural land from farmers to a class that owned these new means of production and collected profits by exploiting labor. The question would be whether the locus of power might be shifting once again.

What is interesting about more contemporary developments in the forces of production is that they are less about capturing value from physical labor and more about capturing data from any activity whatsoever. It is no longer the case that the only "efficient" signal is the price signal. What if there was a mode of production based not on capturing surplus value but on capturing surplus information?

This might be as much the case with Walmart as with Google. Sure, Walmart captures surplus value from its workers, but it also captures surplus information from its workers, its customers, its suppliers, even from the movement of its goods as well. This information is "surplus" in the sense that for every bit of data given away a whole raft of data and metadata remains proprietary.

Google merely perfects this. All it really gives away is access to some particular information—which Google did not itself have to produce. What it gets is the aggregate patterns that it can extract from all of that data. And of course these days it has not only all that search data, but basic telemetry on the movements of any human that has in its possession a cellphone running its Android OS.

None of this, one should hasten to add, is "immaterial." Just as it took an incredible amount of infrastructure to seize power from the old landlord class, so too seizing power from a capitalist class to vest it with something else takes a powerful infrastructure, one no longer about making and distributing things but about controlling that making and distributing.

In sum, considered in a really vulgar way, in terms of the *forces* of production, maybe there's something new going on. Some of the *relations* of production look familiar. This is still an economy that appears to have markets and prices, firms and profits, and so on. But perhaps power is shifting away from owning the means of production, which merely extracts surplus value from labor, toward owning the means of mediation, by which a surplus can be extracted from any activity at all. And so perhaps it is time to relegate the category of capitalism to the museum of historical things. Elements of it persist of course, but it is no longer a concept that describes a totality.

ART AFTER CAPITALISM

SARRITA HUNN AND JAMES MCANALLY

The *after* of capitalism started within the era of capitalism itself—within resistant spaces, texts, and collectivities able to force the era to enter a past tense, even if only momentarily, even if incompletely. For the duration of the essay, we exist within the postmortem of another failed *ism*, attempting to enter some other time altogether, all together.

As Marx proposed, reality is merely "the result of what we do together," the result of our shared labor expanding steadily into new spheres.[1] Artists are among the figures before the end of capitalism, prefiguring its afterlife—working ahead of this reality in anticipation of the ways in which the world could or would be different. We organize alternative schools, spaces of free exchange, communities of critique; we practice and propose direct democracy and non-hierarchical forms of organization and care; we form working groups and co-ops and time banks and collectives; we open our homes, our studios, our bars, our backyards; we look closely, we curate, we care, we make, and we make things happen. Through this sustained experimentation, our work enters the world not as a speculation on possible futures but as an embodiment of them, intervening within the contradictions inherent in capitalism itself.

The Contemporary has come to an end—and with that end a realization that the endless crises over the last decades were not crises in art at all, but in fact a crisis in all other fields—a crisis

in society itself.[2] Consider the "experimental" research, design, and fabrication developments in architecture, biology, economics, theory, and other humanities fields that quickly are forced out of their respective silos and into art once they become too experimental, too speculative. The continual expansion of art corresponds with the narrowing definition of all other realms of inquiry. Bent by market forces, these efforts are splintered and reframed as art when no longer reinforced by funders and intellectual gatekeepers. What does it mean for art to be a transitional, transnational refuge for ideas fleeing from other fields? Further, how does it accomplish this in view of the extraordinary (or, perhaps, ordinary) inequities within the art world itself?

In moments of globalized anxiety and institutional collapse, art isn't able to weather the storm alone. It is, as always, a document of the time and a canary in the mine. As other crises collapse inward toward art, artists work outward toward other ends. The propositions artists in the present are making as they create new institutions, new ways of working, and new ways of working together have more dramatic implications than ever before. *We don't just create work within society, we work toward possible societies.*[3]

This historical shift toward artists creating institutions and other structures that reimagine and sustain particular kinds of contexts, particular communities, and particular ways

1 Quoted from Nicolas Bourriaud, *Make Sure That You Are Seen (Supercritique)* (London: Fact, the foundation for art & creative technology, 2002)

2 In his recent book *In the Flow* (London: Verso, 2016), Boris Groys argues that "The Contemporary" is differentiated from modernity by its obsession with its contemporaneous self; the present, the here and now. He states, "Our contemporary age seems to be different from all other historically known ages in at least one respect: Never before has humanity been so interested in its own contemporaneity. The Middle Ages were interested in eternity, the Renaissance was interested in the past, modernity was interested in the future. Our epoch is primarily interested in itself." (137) Additionally, this obsession with the present inherently prefigures its own demise. He explains, "[Contemporary] Art seems to accept reality, the status quo, as it is. But art accepts the status quo as dysfunctional, as already failed, from the revolutionary or even post revolutionary perspective. Contemporary art puts our contemporaneity into the art museum because it does not believe in the stability of the present conditions of existence, to such a degree that contemporary art does not even try to improve

of working models a world-building impulse perhaps embedded in artistic practice itself. If art is, in fact, a space with the potential for free critical thinking and autonomy, then we must not only defend and expand that space, but develop, improve, and bring our methodologies back to the public at large. Artists within this expanded present are intentionally cultivating and modeling practices that connect the work artists make with the structures they create. The structures artists are creating today are inseparable from the art (and sometimes are the art) and include not only the production and presentation of art, but also its assessment, distribution, and archiving, abandoning boundaries between the art world and an idea of society itself. The contained public of the art world re-enters other publics as an *Öffentlichkeit*[4]; a common world, a public sphere—where public opinion becomes political action.

As Sven Lüttiken has argued, "The public sphere has been described as a fiction that creates its own reality. When people start addressing each other as its representatives, as [the] first modern art critics did, the idea of this sphere becomes an invitation to start behaving as if it actually exists."[5] This impulse cannot be seen as separate from earlier ruptures within late-stage capitalism, and we propose that the structures artists are creating today are not just local and individualized but a new system altogether: an art after capitalism.

Our definition of art after capitalism, then, is *artists creating autonomous models for collective self-organizing that critique current structures through building new ones*. In other words, the practice of autonomy requires critique, yet critique also assumes a process of creation (of building), and if the critique speaks to a more foundational rupture, then that building becomes a form of world-building.

The realm of the imaginary that artists inhabit occupies a simultaneously symbolic and concrete world-making

process that responds to the present by articulating new futures. If the explicit critique within the Occupy movement was that "capitalism isn't working," and subsequent movements reiterated the intersectional inequities at play, then this moment is one in which artists (and others) explore speculative futures no longer contingent on capitalist assumptions—in other words, ways of working past capitalism.

This is first a question of our social imaginaries. We are interested in the ways in which "a new perspective is implicated in our knowledge of the present and visions of the future."[6] Extending this view, Amelia Barikin and Nikos Papastergiadis state further in *Future Publics* that "art in general, and perspective in particular, continue to demonstrate that the mystery of creativity is not in mimesis, the capacity to copy the world, but rather the desire to make possible another vision of the world."[7] Post-capitalist practices move speculatively from a method of seeing, to making, to sustaining, even as they contend with alternate views on multiple fronts.

Art after capitalism builds institutions around art's emergence and circulation that enable its critiques to persist. We cannot be naive about how our works and words circulate among the multiple possible art worlds emerging and dissolving at any moment. We do not just create new narratives, but new structures to sustain us. We create models that exist outside of the dominant structures of the art world and we address one another as its representatives. Institution building is inherent to this way of working past capitalism because our work cannot remain radical without autonomous, interconnected structures to support it. We critique through building. And through this process not just make, but become this public we propose.

these conditions. By defunctionalizing the status quo, art prefigures its coming revolutionary overthrow." (54) Here we propose that by aiming to improve present conditions through enacting speculative futures, art after capitalism inherently means a break with the contemporary age.

3 We are expanding on Jan Verwoert's conclusion in *Self-Organised*; he states "when we speak, *we speak into the void of what society is not but could be.* When we organize, we don't just expand networks, we work towards possible societies." Jan Verwoert, "All the Wrong Examples," *Self-Organised*, ed. by Stine Hebert and Anne Szefer Karlsen (London: Open Editions, 2013), 134.

4 *Öffentlichkeit* is translated most often as "public sphere," arising from Jürgen Habermas's seminal account *The Structural Transformation of the Public Sphere.*

5 Sven Lüttiken, "Secrecy and Publicity: Reactivating the Avant-Garde," *New Left Review* 17 (Sept.–Oct. 2002).

6 Amelia Barikin and Nikos Papastergiadis, "Ambient Perspective and the Citizen's Moving Eyes," *Future Publics (The Rest Can and Should be Done by the People): A Critical Reader in Contemporary Art* (Utrecht: Valiz/BAK, 2015), 105.

7 Ibid., 99.

EVERYTHING THAT IS POSSIBLE DEMANDS TO EXIST.

GOTTFRIED WILHELM LEIBNIZ

THE LONG, DARK NIGHT
OF THE END OF HISTORY
HAS TO BE GRASPED AS AN
ENORMOUS OPPORTUNITY.
THE VERY OPPRESSIVE
PERVASIVENESS OF CAPITALIST
REALISM MEANS THAT EVEN
GLIMMERS OF ALTERNATIVE
POLITICAL AND ECONOMIC
POSSIBILITIES CAN HAVE
DISPROPORTIONATELY GREAT
EFFECT. THE TINIEST EVENT
CAN TEAR A HOLE IN THE GREY
CURTAIN OF REACTION WHICH
HAS MARKED THE HORIZONS
OF POSSIBILITY UNDER
CAPITALIST REALISM.

FROM A SITUATION IN WHICH
NOTHING CAN HAPPEN,
SUDDENLY ANYTHING IS
POSSIBLE AGAIN.

MARK FISHER

Milo Ayden De Luca, Tent Section (detail), from the series *Anti-Capitalist Retreat*, 2012.

PREHISTORY OF A MUSEUM OF CAPITALISM

FICTILIS

C. 200,000 YEARS AGO–3200 BC: PREHISTORY IS NOT WRITTEN

History is what's written, literally. By definition. Everything that happened before we could write about it gets lumped into a category called "prehistory."

As if everything that happened before writing wasn't worth writing about.

3200 BC–PRESENT: HISTORY IS WRITTEN (BY THE VICTORS?)

It's said that history is written by the victors. Winston Churchill is said to have said it, but he's said to have said almost everything. Benjamin said something like it. Orwell said it plainly (as Orwell liked to do).

Putting aside the truth of this statement—the volumes of histories written by the vanquished—as well as its history—who said it first—we might note the apparent implication that history-writing is done retrospectively and competitively. Something is contested, someone wins, someone loses, and then someone writes about it.

In a 1965 book titled *History and Truth*, philosopher Paul Ricoeur says: "We carry on several histories simultaneously, in times whose periods, crises, and pauses do not coincide. We enchain, abandon, and resume several histories, much as a chess player who plays several games at once, renewing now this one, now another."[1] Ricoeur's metaphor is

telling. Even here, from vantage points above, below, in a plurality of histories, we're still playing games.

3200 BC–PRESENT: HISTORY OF MUSEUMS (AND CAPITALISM)

On the history of museums, particularly their relation to colonialism, primitive accumulation, and the global expansion of capitalism, much has been written. We won't add to that here, except to say this: although many of the physical traces of prehistory are exhibited in museums, we can only speculate on the existence of museums, or something like them, in prehistoric times. What we do know is that humans made images before we made writing, before we made history.

C. 1850–1870: HISTORY OF THE WORD "CAPITALISM" (IN WRITING)

The word "capitalist" predates the word "capitalism" by over half a century, appearing in Turgot's 1774 "Reflections on the Formation and Distribution of Wealth," then in William Godwin's *Enquiry concerning Political Justice* (1793). It isn't until the ninth edition of Louis Blanc's *Organization of Work* in 1850 that the word "capitalism" appears, in a passage where Blanc describes the "fallacy" of the "usefulness of capital" being "perpetually confused with what I call capitalism, that is to say the appropriation of capital by some, to

1 Paul Ricoeur, Charles A. Kelbley, and David M. Rasmussen, *History and Truth* (Evanston, IL: Northwestern University Press, 2007).

2 Louis Blanc. *Organization of Work* (London: Forgotten Books, 2017).

the exclusion of others."[2] Then in 1851, the French politician and philosopher Pierre-Joseph Proudhon starts using the term *capitalisme*, and its usage begins to widen in English and French. Proudhon, the first person to describe himself in a positive way using the traditionally pejorative term anarchist, begins also a tradition of usage of capitalism that is still with us, as a negative term associated primarily with critics. Adam Smith, who is often regarded as the father of capitalism, never once used the term that was popularized by the so-called father of anarchism. However, Karl Marx, perhaps the most famous critic of capitalism, though he writes frequently of the "capitalist mode of production" and of "capitalists," rarely uses the term "capitalism." It appears only twice in the first volume of *Capital* (1867) and nine times in the following two volumes, and was read back into his writings, read where it wasn't written, by later Russian translators.

1940: HISTORY OF THE IDEA OF A MUSEUM OF CAPITALISM—MAO ZEDONG

The idea of a museum of capitalism is first recorded by Mao Zedong, who writes: "The ideological and social system of capitalism has also become a museum piece in one part of the world (in the Soviet Union), while in other countries it resembles "a dying person who is sinking fast, like the sun setting beyond the western hills," and will soon be relegated to the museum."[3] The passage contrasts what is considered a dying "ideological and social system" with the young, vital system replacing it—communism; the "also" in the first part refers of course to feudalism, the system capitalism is said to have previously replaced. Though history may not have looked kindly on some of Chairman Mao's other speculations, the prediction of an eventual museum of capitalism may still be considered in itself, apart from the political

motives at work in the context of this writing.

2010: HISTORY OF THE IDEA OF A MUSEUM OF CAPITALISM—ALEX CALLINICOS

The idea of a retrospectively-oriented Museum of Capitalism is revisited in a different context some seventy years after Mao Zedong's vision, during political theorist Alex Callinicos's opening remarks at the 2010 "Idea of Communism" conference in London. Although this time the idea has more the tone of a speculative fancy than a confident assertion, at a time when capitalism was felt to be in crisis following the 2008 collapse. After describing a recent trip to the Museum of Apartheid in South Africa, Callinicos conjectures the eventual existence of a similar "museum of capitalism."

2010–PRESENT: HISTORY OF THE IDEA OF A MUSEUM OF CAPITALISM—VARIOUS SOURCES

Museum of Capitalism founders, not waiting for the "one day" that Alex Callinicos conjectured, nor the "soon" that Mao envisioned beyond the western hills, begin to make concrete plans for the opening of the museum. After reading about Callinicos's remarks in 2010, they register the domain name online.

Maybe the prehistory of the Museum of Capitalism is not when there is *no* writing about it, but when there is *only* writing about it. Because the Museum will not just be something to write about, any more than it is an image of the future, offered up for tidy consumption. It's a future that you can step inside, and walk around. It's opening soon, and we're all invited.

We might say, then: The *history* of the Museum of Capitalism begins now.

2003: HISTORY OF THE MUSEUM OF CAPITALISM (ON THE INTERNET)

Cuban artist Diango Hernández buys the URL "themuseumofcapitalism.com"

3 Mao Tse-Tung, *Selected Works of Mao Tse-Tung: Volume II* (Beijing: Foreign Languages Press, n.d.).

and redirects it to the Google search engine home page. The gesture circulates in a limited way online in the art world, before the domain is eventually left to expire.

As of March 2017, the domain is for sale from registrar hugedomains.com for $3,595, or can be financed for twelve monthly payments of only $299.58 per month. Hugedomains is one of many internet real estate speculators who acquire expired domains and park them on simple pages advertising their sale. On this page, like all its others using this basic landing page template, hugedomains.com urges potential buyers: "Start using this domain today."

1946–PRESENT: MUSEUMS AND PROGRESS

The first modern museums appear alongside the modern concept of progress in the eighteenth century, and the two are closely related. Writing in the context of postwar Germany, philosopher Herman Lubbe sees museums as stabilizing forces in times of rapid social change. According to Lübbe, the museum is, "to begin with, a means of salvaging cultural remnants from processes of destruction, a mechanism exposed irreversibly to whatever the present process of reproduction selects out in the process of cultural evolution."[4]

1997: US DEPT. OF RETRO WARNS: "WE MAY BE RUNNING OUT OF PAST"

No less an authority than the United States periodical The Onion reports of an imminent "national retro crisis," cautioning that "if current levels of US retro consumption are allowed to continue unchecked, we may run entirely out of past by as soon as 2005." According to US Retro Secretary Anson Williams, "the US's exponentially decreasing retro gap is in danger of achieving parity with real-time historical events early in the next century, creating what leading retro experts call

a 'futurified recursion loop,' or 'retro-present warp' ... leaving us to face the threat of retro-ironic appreciation being applied to present or even future events ... a potentially devastating crisis situation in which our society will express nostalgia for events which have yet to occur."[5]

2014: PROLIFERATION OF CONTEMPORARY MUSEUMS

The Washington Post reports that there are approximately 35,000 museums in the United States, more than the number of every Starbucks and McDonald's retail locations combined. The claim is somewhat contestable, given that the 35,000 figure originating from the Institute for Museum and Library Services counts "related organizations" like botanical gardens and nature centers, and does not include Starbucks and McDonald's retail locations.

C. 1850–1870: HISTORY OF THE WORD "CAPITALISM" (IN MODIFIED FORMS)

Like museums, capitalisms proliferate. And words for capitalisms, words being sort of like little museums for thoughts. The field of economics already has its own subfield on "varieties of capitalism," though the word "capitalism" itself fell out of fashion as an explanatory term in the last few decades of the twentieth century. This hasn't stopped scholars outside economics proper from coining many new terms— some by the addition of simple prefixes, others hyphenated with unlikely adjectival modifiers—to describe how capitalism changes and enters new domains of life.

As part of its founding collection, the Museum of Capitalism maintains an inventory of such terms, and invites researchers to study, catalog, and adapt them for use in their own work.

4 Quoted in Wolfram Kaiser, Stefan Krankenhagen, and Kerstin Poehls, *Exhibiting Europe in Museums: Transnational Networks, Collections, Narratives, and Representations (Museums and Collections)* (Berlin: Berghahn Books, 2014).

5 "U.S. Dept. Of Retro Warns: 'We May Be Running Out Of Past.'" *The Onion*, November 4, 1997.

1980S–PRESENT: THE QUALITY (AND QUANTITY) OF BEING "POST-"

In the years following the ascendancy of poststructuralism in academic discourse, there appears a multiplication of "posts" across many disciplines, to the point where we must consider overextensions of the term like the unfortunate "post-racial" alongside difficult, delicate terms like post-capitalism, or even post-post-colonialism. Without engaging in the familiar conservative dismissal of these constructions as mere academic jargon, we might wonder how an increasing periodization of history combines with an actual longing for change to create such a dizzying array.

1991–PRESENT: "LATE" AND "TOO LATE"

In a widely cited essay about postmodernism, the "post-" that seems to have spawned so many others, Frederic Jameson uses economist Ernest Mandel's term "late capitalism" in the title, which offers another step preceding the status of "post-ness"—lateness—with the same teleological direction. The never-quite-arriving future shares a status with the past, or with history itself. Jameson writes: "we are condemned to seek History by way of our own pop images and simulacra of that history, which itself remains forever out of reach."

The term Jameson helps popularize will be spread across the theoretical landscape and transformed, by Hakim Bey and others, into the term "too-late capitalism." For those skeptical of a museum's potential in the face of climate change, or the statistical certainty of global ecological uncertainty, the term will become a kind of epithet or perhaps epitaph: it is, or it was, too late.[6]

2003: OBJECTIVIST ASKS, "WHY NO MUSEUM OF CAPITALISM?"

In 2003, the same year as Diango Hernández's redirect piece, David Kelley, Founder and Chief Intellectual Officer of The Atlas Society, a group promoting the Objectivist philosophy of Ayn Rand, pens a blog post entitled "Why is there no Museum of Capitalism?" He writes: "Many of the great museums were created with money from successful industrialists like Andrew Carnegie and John D. Rockefeller and still rely on wealthy businessmen for large contributions. Wouldn't it be fitting to create a museum where the source of that wealth—the realm of production and trade—could be studied, contemplated, and celebrated?"[7]

History answers Mr. Kelley's question: Yes. Yes, it would be fitting.

1989: STEIN'S LAW

In a 1989 publication of conservative think tank American Enterprise Institute, Herbert Stein, former chief economist to Presidents Nixon and Ford, formulates what will become known as "Stein's Law." The law is most often expressed this way:

"If something can't go on forever, it won't."[8]

This proposition appears in an article titled "Problems and Not-Problems of the American Economy," in which Stein attempts to counter the argument that action must be taken to stop something that will inevitably stop of its own accord. Setting aside Stein's use of the statement, its basic tautological truth (that something that can not happen will not happen) will be leveraged in future statements—statements made as actions—with different definitions of what in the American economy constitute "problems" and "not-problems."

1946–2001: WINDOWS OUT OF ART, WINDOWS INTO HISTORY

In the 2001 book *Modernity and the Holocaust*, Zygmunt Bauman emphasizes the crucial non-exceptionality of the Holocaust, how its logic is fundamental to modernity rather than

6 Fredric Jameson, *Postmodernism, Or, The Cultural Logic of Late Capitalism* (Durham: Duke University Press, 1992).

7 "For a Museum of Capitalism." The Atlas Society, January 6, 2003.

8 Stein's original formulation was: "If something cannot go on forever, it will stop."

some kind of aberration. The Holocaust should be seen, Bauman writes, "as a window, rather than a picture on the wall. Looking through that window, one can catch a glimpse of many things otherwise invisible."

In 1946, as French painter Pierre Bonnard is leaving the Louvre in Paris for the very last time, he famously tells a friend, "The best things in museums are the windows."[9]

AUGUST 29, 2016: "ANTHROPOCENE" RECOMMENDED FOR APPROVAL

At the thirty-fifth International Geological Congress in Cape Town, South Africa, the Anthropocene Working Group recommends officially adopting the name "Anthropocene" for the current geological era.

Leaving aside the question of the appropriateness of a term that glosses over the differential responsibility within the category "Anthropos" for the radioactive elements, plastic particles, and atmospheric carbon spread across the globe as markers of this era, it is useful to consider some of the cultural effects and political force of the naming. Jeremy Davies describes how the term asserts a "pressing need to re-imagine human and nonhuman life," and Robert Macfarlane writes that the Anthropocene "delivers a massive jolt to the imagination" that "charges us with systemic change."[10]

Museum of Capitalism founders, though skeptical of the abilities of science or education alone to cause systemic change, do appreciate the role museums play as educative institutions, as well as the power of naming.

MARCH 11, 2017: MUSEUMS OF CAPITALISM GLOBAL SUMMIT

Representatives from three different museums of capitalism meet in Berlin for a "Museums of Capitalism Global Summit." One museum is based in Brussels, another in Berlin, and the third in Oakland, California. Each

has been organizing exhibitions and related museum programming in parallel for the past two years, and each discovered the others after having already begun their own museum projects. Somehow, they each independently struck upon the same idea at almost exactly the same time. It's as if something is in the air, as if history itself, in this moment, has a certain direction.

They hold a day-long meeting, discussing their different approaches and local contexts, as well as the theoretical background and practical challenges of their work and potential partnerships. A loose alliance is formed. In the evening, after the meeting, a public panel discussion is held.

Though some in attendance call the meeting historic, it remains to be seen what will eventually come of it, and exactly which direction its history will go.

1800–2016: "THE FUTURE IS UNWRITTEN"

It's said that the future is unwritten. Joe Strummer (of The Clash) is said to have said it, or at least they made a movie about him with that title. "Doc" Brown says it to Marty and Jennifer at the end of *Back to the Future Part III*. Orwell may as well have said it, in *1984* (writing about the future).

In this, the future is like the past. It's like prehistory, which by definition, is unwritten.

Leaving aside the truth of this statement, we might look to its history in written form. Google's ngram viewer, which searches texts of millions of books scanned from libraries across the world, shows a gradual upward curve indicating the phrase's increasing appearance in print. The future seems to be increasingly unwritten, or less written, as time goes on, while the phrase itself, as expressed in English at least, seems to contradict its own message by being less and less unwritten, or more written.

The curve of the graph showing this phrase's appearance in print matches

9 Quoted in Michel Terrasse, *Bonnard at Le Cannet*, where Bonnard is described peering intensely at every painting in the Louvre, as well as each window. Interestingly, the author notes that windows are ubiquitous in Bonnard's own body of work—a biographical detail which alters the meaning of the statement as first uttered.

10 See Jeremy Davies, *Birth of the Anthropocene* (Berkeley: University of California Press, 2016 and Robert Macfarlane, "Generation Anthropocene: How Humans Have Altered the Planet Forever," in The *Guardian*, April 1, 2016. For critical discussion of the Anthropocene concept, see Christophe Bonneuil and Jean-Baptiste Fressoz's *The Shock of the Anthropocene: The Earth, History and Us* (New York and London: Verso, 2017) and *Anthropocene or Capitalocene?: Nature, History, and the Crisis of Capitalism*, ed. by Jason W. Moore (Oakland: PM Press, 2016).

pretty closely the curves of various economic indicators like Gross Domestic Product per capita in the world's major capitalist countries, which themselves mirror the curves of various environmental indicators of climate change. It's as if we're reminding ourselves, in writing, of a sense of possibility, even as a foreclosing of possibility is inscribed into the landscape, to be read, recorded, and committed to memory.

CIRCA 200,000 YEARS AGO–PRESENT: THE BLIP OF CAPITALISM
Humans keep on making things and exchanging things, one way or another.

What does it mean to write a prehistory of anything? Does a prehistory include all of the things that happened but weren't registered as important and led to something that was? Is prehistory only spoken, so that writing history is writing a history of the unspoken?

Little has been written about all of the things we made and exchanged, during this time. We may not correct that here, but we will point out that if the entirety of human history—anatomically modern, culturally recognizable human history—were to be condensed into the past fifteen minutes it took to read this, the period we think of as defined by capitalism would last only for the final one second of this essay.

Look up, and stop reading for one second.

Milo Ayden De Luca, Anti-Capitalist Festival Birdseye (detail), from the series *Anti-Capitalist Retreat*, 2012.

TO BE TRULY RADICAL IS TO MAKE HOPE POSSIBLE, RATHER THAN DESPAIR CONVINCING.

RAYMOND WILLIAMS

AFTERWORD

KIM STANLEY ROBINSON

People living in the capitalist period seemed to feel it was a massively entrenched system that could never be changed. This is mysterious, and should cause us to ponder: what do we now regard to be strong and permanent, that is actually weak and temporary?

Hegemony: like fish in water.

Easier to imagine the end of the world than the end of capitalism, they said. The two entities had gotten confused in people's minds.

But what can't happen won't happen.

Maybe this is one way to look outside your frame. What can't happen, won't happen. So what do the laws of physics allow in any given situation? It's not as broad a parameter as you might think. Cognition is rife with systemic errors. We're not good at thinking with physics. We are often magical thinkers, and not in a good way. Simply mistaken. Cognitive errors. At least ten systemic cognitive errors have been identified by scientific investigations of cognition. It's enough to make you think.

Life is robust. Mass extinction events happen, but life on Earth goes on. Until the sun goes nova. The world is not going to end for about five billion years. Then it will. Think about the number five billion for a while.

Recall that moment when the global civilization began to set target limits on their disaster. Cap the carbon dioxide in the atmosphere at 450 parts per million. Cap the temperature rise at 1.5 degrees Celsius. Cap the number of human-caused species extinctions at a million. Cap the number of human deaths by famine at a billion.

Was that the moment? Do you determine the ends first, and then the means to get there?

Any moment is a mix of a residual history and an emergent future. Capitalism was therefore a mix of feudalism and the postcapitalism (poorly named) that we live in now.

Our moment's residual is therefore capitalism. This is a dangerous fact, because capitalism wants hegemony, always. Our emergent: first, let's not name it post-postcapitalism. Provisionally we could call it harmony, or climax, or peace. But we are not there. The dead hand of the past clutches us, as always. It's dangerous.

Consider capitalism's residual, feudalism. In feudalism, about one percent of the human population dominated the wealth and power created by the rest. The majority were miserably poor. There was a small managerial class that administered the system for the rich rulers.

Sound familiar? Yes, because that didn't go away in capitalism. It was the residual that resided. Getting rid of that was what marked our period as different, it is what defines the postcapitalist period as such. But capitalism is still our residual, so that latent drag

toward injustice is always there.

It's like living with a dog. Dogs used to be wolves. Your dog could still turn on you and rip your throat out. But it's been domesticated. Treat it right and it will never think to attack you. You are relatively safe, if you respect the situation. Still, it makes sense to push hard for whatever is emergent, to escape that danger. But also, feed your dog.

For those who lived under capitalism, the time "when man was wolf to man," there were two problems they felt were beyond their imagination to solve:

What could possibly replace capitalism? And how could they start to get there?

The emergent is always emerging. History never stops.

In the Basque corner of Spain there existed a small postcapitalist project called Mondragon. It started in the small town of that name, under the Franco dictatorship. A young Catholic priest, José María Arizmendiarrieta, was assigned to minister to the local Basque population. He arrived in 1941 and spent the next fifteen years talking about ways of organizing local industries into a mutually supportive system of cooperatives. These eventually included local banks. The system was not large, but it was not small. It was emergent.

In Mondragon, employees owned their companies. They hired their management. Highest salaries could be no more than ten times the lowest salaries, with the lowest providing an adequate sufficiency for a healthy life. Profits when they came were split three ways, between employees, reinvestments in the coops, and charities chosen by employees.

All this was legal almost anywhere in the world at that time. It could have been universal then, as it is now.

But how to start that change? How to break the hold of capitalism before the mass extinction became unstoppable?

Capitalism always staggered from crisis to crisis. Boom and bust. For most of its run it profited from these crises, each one further entrenching the power of the wealthy. Even so, these crises were still crises. Clues could be gleaned from studying them. There were a lot to study.

Greed is insatiable.

The system was systemically fragile. It was over-leveraged. It was legal at that time to loan more money out than you had in hand, and to borrow more money than you could pay back at any given time. This was routine in the system's ordinary workings. Banks routinely leveraged their assets by a factor of 100. If the money they took in was interrupted even briefly, they couldn't meet their obligations. Everything had to stay moving, there could be no interruptions to the flow of money.

Capitalism was therefore at all times a bubble. Bubbles create derivative bubbles. When bubbles pop, crises result. Recessions, depressions; meaning hunger, misery, death.

To avoid depressions, governments created and gave money to the banks that popped when bubbles popped. This solution played out most obviously in the crisis of 2008.

Clinamen: a swerve in a new direction.

It was pointed out that when governments bailed out banks, they could at that moment nationalize those banks. Finance, like money itself, would then become a fully owned subsidiary of governments.

If the governments that nationalized the banks were democratic, then finance would be democratic. It would become a tool of the people, used by the people and for the people.

It was further pointed out that banks, being systemically overleveraged, were always bubbles, and therefore always vulnerable to popping.

You could pop them.

Their borrowing and loans were always secured by people's regular payments of mortgages, insurance payments, utility payments, student loans, and so on.

People want illiquidity. Home, health, school, utilities: in financial terms, these are illiquid assets. And we want them illiquid. That equates to stability.

Finance dealt in liquidity, it wanted liquidity.

In a competition where liquidity is advantaged by law, liquidity wins. It's a name for speed in a game where speed wins. So finance dominated people, because that's how capitalism worked. Its laws mandated that result. There was no chance for illiquidity (i.e. people) to win in that contest.

But finance was overleveraged, and relied on people making their steady stream of payments and thus guaranteeing their own illiquidity, which meant their loss in the game of finance, but also their homes, health care, and possessions.

But if everyone stopped making their regularly scheduled payments at the same time—a pretty popular action, it seems—there would be too many people to put in jail, and—

Pop.

"Like a pin through a castle wall, and no more king." —Shakespeare

At that point, when the bubble was needled by the people, there also had to be a plan in place, which was this:

Bail out the banks, and thus the economy, by nationalizing them.

Nationalize the banks.

"—that government of the people, by the people, and for the people, shall not perish from this Earth."

Note the imperative mood. "Shall not"—an exhortation. A call to act. Citizen action. Civil disobedience is a citizen action. A revolution is a citizen action.

So when finance tried to take over government—

By now you will have recognized this brief description of the first step in what is sometimes called the Invisible Revolution. Invisible, because the masses of people in the city squares, which still happened from time to time, were not the crucial aspect of the changes that took place. The revolution was happening elsewhere, in the moneysphere itself. People did it from home. They did it online. They did it by acting as the hedge fund managers of their own lives, which finance itself had forced them to become. It was a strategic defaulting, which is something finance had been doing all along. A mass strategic defaulting, a people's strategic default. Also called revolution.

Laws change, people change. Hegemony changes, life changes. History changes. But always for any single individual these things happen offstage, over the horizon. They are things one reads about, things one is told about. You live your life, the world happens. Every once in awhile you get a chance to do something political, something historically strategic. Then you go out and live in a different reality. It's mysterious.

So, the Invisible Revolution. Governments having bailed out and seized finance, there was suddenly government money to spend on people. Progressive taxation placed on capital assets, the so-called Piketty tax, added to that new financial ability to act in the public good, for people and planet. Health care, education, living wage, pensions. National service devoted to ecological restoration, and care for the people who needed care. The mondragooning of the economy. These and many other aspects of post-capitalism were not only now affordable, they were the definition of what civilization did, what it was for.

And so, no mass extinction event— meaning the anthropogenic extinctions

have been held to less than one million.
Best we could do, given the situation
we were handed. Not a rousing victory;
not a total success. Not a utopia. Out-
standing problems proliferate, as you
know. There is still a need for harmony,
climax, peace. Getting there will not
be easy. We have to feed the dog. We
have to keep identifying and helping the
emergent, we have to analyze our bubble
and pop it, we have to make the next
plan. That will always remain our task.
History never stops—not for five billion
more years, anyway.

But here, now, this exhibit exists
to remind us that there came a point
in time when our ancestors, the people
of the twenty-first century, joined in
solidarity and took citizen action. And
things changed. And here we are.

It's easier to imagine the end of capital-
ism than it is the end of the world.
Q.E.D.

Quod erat demonstrandum: "what was to
be demonstrated."
 "The abbreviation is often written
at the bottom of a mathematical proof.
Sometimes translated loosely into
English as "The Five Ws": w.w.w.w.w.,
which stands for "Which was what we
wanted."

Indeed.

TRANSITION TIMES
ARE TRAGIC: WE
ONLY SEE THE
OUTLINES OF THE
NEW, WHILE STILL
SUBJECT TO
THE LIMITS OF THE
OLD. WE STUMBLE
FORWARD BETWEEN
THESE TWO
EXTREMES

CHRISTIAN MARAZZI

Milo Ayden De Luca, Itinerant Beacon 2 (detail), from the series *Anti-Capitalist Retreat*, 2012.

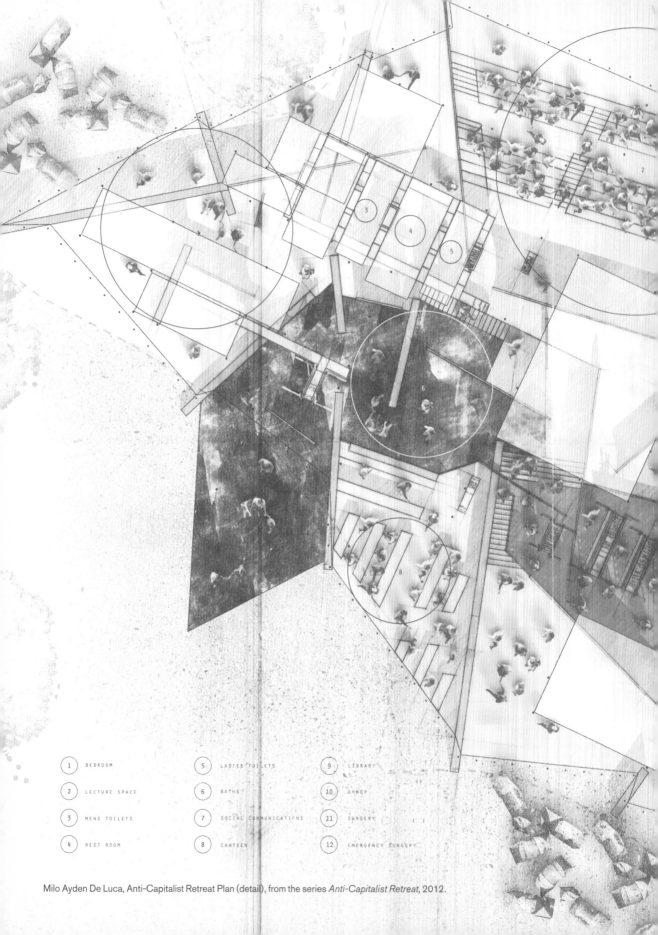

Milo Ayden De Luca, Anti-Capitalist Retreat Plan (detail), from the series *Anti-Capitalist Retreat*, 2012.

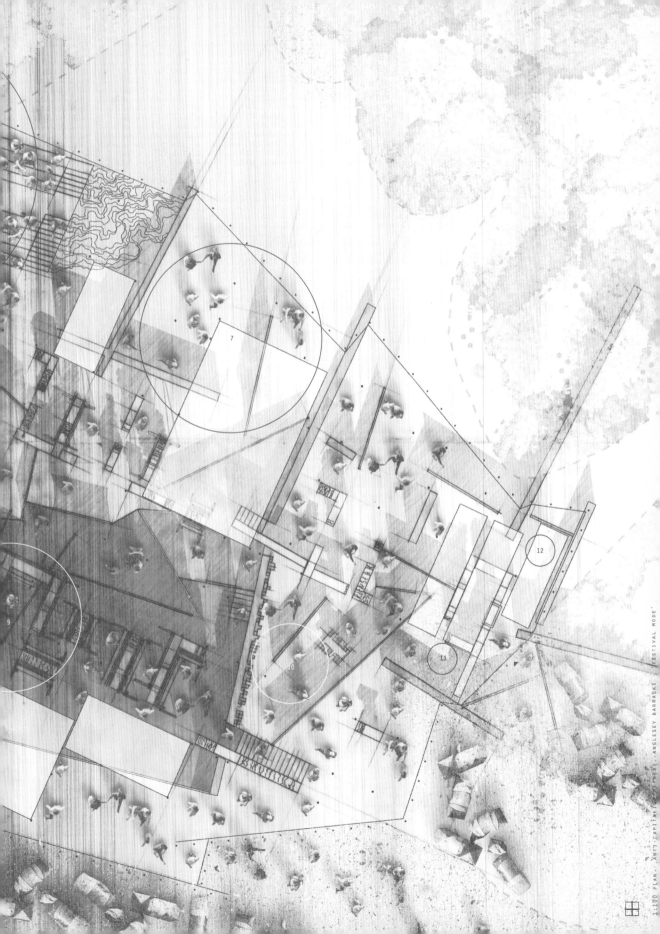

CONTRIBUTORS

Chiara Bottici is a philosopher and writer. She is an Associate Professor of Philosophy at the New School for Social Research and the author of *Imaginal Politics: Images beyond Imagination, The Imaginary, A Philosophy of Political Myth*, and *Men and States*. With Benoit Challand, she co-authored *Imagining Europe: Myth, Memory, Identity and The Myth of the Clash of Civilizations*. Her short stories have appeared in *Il Caffe illustrato*, while her novel *Per tre miti, forse quattro* was published in 2016 and reviewed as the beginning of a "new magic that breaks the order."

Ingrid Burrington is an artist, writer, and educator. She has previously written about infrastructure, power, and geography for *The Atlantic*, *Fusion*, and *Dissent*, among other outlets. She's also the author of *Networks of New York: An Illustrated Field Guide to Urban Internet Infrastructure*. Her artwork and research have been supported by Eyebeam Art and Technology Center, The Center for Land Use Interpretation, and Data and Society Research Institute. She lives on a small island off the coast of America.

Steven Cottingham is an artist. His work has been exhibited in both professional and guerrilla contexts, including the Wellcome Collection (London, UK), Agora (Berlin), Centro Desarrollo de las Artes Visuales (Havana), Chamber (Milwaukee, WI), The Luminary (St. Louis, MO), and the Art

Gallery of Alberta (Edmonton, AB). Recent residencies occurred at Fogo Island, Zentrum für Kunst und Urbanistik (Berlin), and the Skowhegan School of Painting and Sculpture (Skowhegan, ME). His current interests include love and labor.

Milo Ayden De Luca was educated at University College London's Bartlett School of Architecture, with a background in photography. He works with a variety of different disciplines and mediums, all drawing upon the spatial, formal and compositional strategies of design. With a special focus on humanist architecture, combining the practical, material, and ephemeral qualities of architecture, tackling the economical and social issues of modern society is one of De Luca's key missions. His work is online at www.milo-aydendeluca.com.

Heather Davis is currently a post-doctoral fellow at the Institute for the Arts and Humanities at the Pennsylvania State University, where she researches the ethology of plastic and its links to petro-capitalism. She is the editor of *Art in the Anthropocene: Encounters Among Aesthetics, Politics, Environments and Epistemologies* and the forthcoming *Desire Change: Contemporary Feminist Art in Canada*. Her writing can be found at heathermdavis.com.

T. J. Demos is Professor in the Department of the History of Art and Visual Culture at University of California, Santa Cruz, and

Founder and Director of its Center for Creative Ecologies. He writes widely on the intersection of contemporary art, global politics, and ecology and is the author of *Decolonizing Nature: Contemporary Art and the Politics of Ecology*; *The Migrant Image: The Art and Politics of Documentary During Global Crisis*—winner of the College Art Association's 2014 Frank Jewett Mather Award—and *Return to the Postcolony: Spectres of Colonialism in Contemporary Art*. Demos co-curated *Rights of Nature: Art and Ecology in the Americas*, at Nottingham Contemporary in January 2015, and organized *Specters: A Ciné-Politics of Haunting*, at the Reina Sofia Museum in Madrid in 2014. He is currently completing a new book for Sternberg Press entitled *Against the Anthropocene: Visual Culture and Environment Today*.

J. K. Gibson-Graham is the pen name of feminist economic geographers Katherine Gibson and the late Julie Graham. Katherine Gibson is currently professor at the Institute for Culture and Society, Western Sydney University. J. K. Gibson-Graham founded The Community Economies Research Network (CERN) and the Community Economies Collective (CEC), international collaborative networks of researchers who share an interest in theorizing, discussing, representing and ultimately enacting new visions of economy. Books authored and co-authored by J. K. Gibson-Graham include

The End of Capitalism (As We Knew It): A Feminist Critique of Political Economy, A Postcapitalist Politics, Take Back the Economy: An Ethical Guide for Transforming our Communities, and *Making Other Worlds Possible: Performing Diverse Economies.*

Jennifer A. González is Professor in the History of Art and Visual Culture at the University of California, Santa Cruz, and also teaches at the Whitney Museum Independent Study Program, New York. She has received fellowships from the Ford Foundation, the American Association of University Women, and the American Council of Learned Societies. She has published in *Frieze, Bomb, Diacritics, Camera Obscura, Open Space,* and *Art Journal.* She is the author of two books, *Subject to Display: Reframing Race in Contemporary Installation Art*—a finalist for the Charles Rufus Morey Book Award—and *Pepón Osorio.*

Kyle Henderson is an artist working between the fields of art, architecture, and interior design. His work spans various subjects and scales but is uniformly bound by an architectural aesthetic; disparate and spontaneous mark making becoming controlled within a repetitive layering of line. Interest in his work has led to a diverse range of projects and collaborations. His artwork is exhibited internationally and at www.kylehenderson.co.uk.

Sarrita Hunn is an interdisciplinary artist whose often collaborative practice focuses on the culturally, socially and politically transformative potential of artist-centered activity. She is co-founder/editor

(with James McAnally) of *Temporary Art Review,* an international platform for contemporary art criticism that focuses on alternative spaces and critical exchange among disparate art communities. Recent projects include "Field Perspectives: Art Organizing within Accelerated Capitalisms" (with Miami Rail), a series of essays for the 2016 Common Field Convening (Miami, FL); *To Make a Public: Temporary Art Review 2011–2016,* a five year anthology published with Institute for Connotative Action (INCA) Press; Inter/de-pen-dence: the game (with Christine Wong Yap) performed at SOHO20 (Brooklyn, NY); and "Imagining Alternative Art Criticism" workshops at Pelican Bomb Gallery X (New Orleans, LA) and Louise Dany (Oslo, Norway).

Kevin Killian is a San Francisco-based novelist, poet, playwright, and art writer. He has edited *My Vocabulary Did This to Me: The Collected Poems of Jack Spicer* (with Peter Gizzi), along with a biography, *Poet Be Like God: Jack Spicer and the San Francisco Renaissance* (with Lewis Ellingham). Other critical projects include *The Kenning Anthology of Poets Theater 1945–1985* (with David Brazil) and the forthcoming volume *Writers Who Love Too Much: New Narrative Writing, 1977–1997* (with Dodie Bellamy). Since 1985 he has written over fifty plays for San Francisco Poets Theater, including full length collaborations with Norma Cole, Barbara Guest, Leslie Scalapino, and Brian Kim Stefans. His papers and photographs have recently been acquired by the Yale Collection of American Literature for the Beinecke Library.

Sasha Lilley is a writer and radio broadcaster. She's the co-founder and host of the critically acclaimed program of radical ideas, Against the Grain, originating from KPFA Radio in the San Francisco Bay Area. She's the author of *Capital and Its Discontents: Conversations with Radical Thinkers in a Time of Tumult* and co-author of *Catastrophism: The Apocalyptic Politics of Collapse and Rebirth.* Sasha is the series editor of PM Press' political economy imprint, Spectre—decidedly more Karl Marx than Ian Fleming.

Rose Linke is a writer and artist based in San Francisco. Her work has been seen at the ZERO1 Biennial, during San Francisco's Litquake Festival, within *THE THING Quarterly,* and projected onto The Great Wall of Oakland. She cares most for things that don't exactly have concrete form: words as they are being spoken and filling the air, landscapes imagined and real, skies and faces, human memory, and ruins.

Lucy Lippard is a writer/ activist/sometime curator, and author of twenty-four books on contemporary art, activism, feminism, place, photography, history, archaeology (and a couple of experimental fictions). Her most recent book is *Undermining: A Wild Ride Through Land Use, Politics and Art in the Changing West* (2014). She lives off the grid in rural New Mexico, where for twenty years she has edited the monthly community newsletter, *El Puente de Galisteo.*

James McAnally is an artist, curator, and critic based in St. Louis, MO. He is the co-founder (along with Sarrita Hunn) of *Temporary*

Art Review, an international platform for contemporary art criticism that focuses on artist-run and alternative spaces. McAnally is also a founder, co-director, and curator of The Luminary, an independent space based in St. Louis, MO. In his artistic practice, he works as a part of the collaborative US English. He has exhibited, written, and lectured widely in contexts such as the Walker Art Center, Queens Museum, Pulitzer Arts Foundation with Ballroom Marfa, Kadist Art Foundation, Gwangju Biennial (with INCA Seattle), Carnegie Mellon University, Kansas City Art Institute, Transformer, and Moore College of Art and Design. McAnally is a 2015 recipient of the Creative Capital | Andy Warhol Foundation Arts Writers Grant for Short-Form Writing.

Valeria Mogilevich has been working at the intersection of education, design, and community engagement for over a decade. She is a visual storyteller who designs tools and curricula that help people participate in the processes that shape their lives. Her work takes complex issues and makes them more accessible through design. She also consults independently on youth education and design for social impact with cultural institutions, grassroots organizations, and education non-profits. She is the former Deputy Director of The Center for Urban Pedagogy (CUP) and holds a Bachelor of Arts from Brown University in Modern Culture and Media. You can find her at valeriamogilevich.com.

Chantal Mouffe is a Senior Research Fellow at the Centre for the Study of Democracy at the University of Westminster. Her books include *The Return of the Political*, *Hegemony and Socialist Strategy* (with Ernesto Laclau), *The Dimensions of Radical Democracy*, *Gramsci and Marxist Theory*, *Deconstruction and Pragmatism*, *The Democratic Paradox*, and *The Challenge of Carl Schmitt*, all from Verso.

Ian Alan Paul is a transdisciplinary artist, theorist, and curator. His practice spans experimental documentary, critical fiction, and media art, and aims to produce novel conditions for the exploration of contemporary politics, ethics, and aesthetics across global contexts. He has lectured and exhibited internationally, and has had his work featured in *The Atlantic*, *Al Jazeera*, *Le Monde*, *Art Threat*, *Mada Masr*, *Jadaliyya*, *Art Info*, and *C Magazine*, among others. Ian is currently part of the faculty at Al-Quds Bard in Palestine, and a portfolio of his work can be found at www.ianalanpaul.com.

Sayler / Morris (Susannah Sayler and Edward Morris) use diverse media and participatory projects to investigate and contribute to the development of ecological consciousness. Their work has been exhibited in diverse venues internationally, including: MASS MoCA, the Cooper Hewitt Design Museum, the Walker Art Center, The Kunsthal Rotterdam, The Museum of Contemporary Art/Denver, the Museum of Science and Industry (Chicago, IL), etc. Sayler / Morris have been Smithsonian Artist Research Fellows and Artist Fellows at The Nevada Museum of Art's Center

for Art + Environment. In 2008–09 Sayler / Morris were Loeb Fellows at Harvard University's Graduate School of Design. In 2016, they were awarded the 8th Annual David Brower Art/Act Award. They currently teach in the Transmedia Department at Syracuse University, where they co-direct The Canary Lab.

Lester K. Spence is an Associate Professor of Political Science and Africana Studies at Johns Hopkins University. His two award-winning books (*Stare in the Darkness: The Limits of Hip-hop and Black Politics*, and *Knocking the Hustle: Against the Neoliberal Turn in Black Politics*) are among the first to chart the adverse impact of neoliberalism on black communities. He plots and plans in his spare time.

Riiko Sakkinen is a Finnish-born artist now based in Spain. He is the founder of Turbo Realism, a twenty-first-century art movement which depicts globalized capitalism with mocking verisimilitude. He does drawings, paintings, murals, objects, slideshows, installations, and interventions about various aspects of consumer culture. He believes, according to Pablo Picasso's words, that "art is not made to decorate rooms—it is an offensive weapon in defense against the enemy." Sakkinen's works have been exhibited widely around the world in galleries, museums and biennials, and his works are included in the permanent collections of several museums, including The Museum of Modern Art, New York; Helsinki Art Museum and Kiasma Museum of Contemporary Art, Helsinki.

Stephen Squibb is a founding member of Woodshed Collective theater company, producers of *12 Ophelias, The Confidence Man* (Best of 2009, *Gothamist*), *The Tenant* (Best of 2011, *L Magazine*), and *Empire Travel Agency* (Best New York Theater of 2015, *Guardian*) His work as a writer and/or an editor has appeared in *Artforum, Frieze, Monthly Review, Jacobin*, and *n+1*. With Keith Gessen he edited *City by City: Dispatches from the American Metropolis*, which was named one of the best nonfiction books of 2015 by Publisher's Weekly. He is ABD in the English department at Harvard University & edits e-flux journal alongside Julieta Aranda, Brian Kuan Wood, and Anton Vidokle.

Kim Stanley Robinson is a Californian science fiction writer, married to Lisa Nowell. He has published twenty books and was sent to Antarctica by the National Science Foundation. He is the author of the Mars trilogy. A *New York Times* bestseller, he has been translated into twenty-four languages. His most recent novels include *New York 2140, Aurora, Shaman, 2312, Galileo's Dream*, and *Green Earth*.

Calum Storrie is a writer and exhibition maker. He has designed exhibitions for London's National Gallery, the Royal Academy and the National Portrait Gallery. Over the last few years he has worked on a series of acclaimed displays for the Wellcome Collection, including: *Skeletons: London's Buried Bones, Madness and Modernity* and *Forensics*. He is currently collaborating with Nobel Prize laureate Orhan Pamuk on the traveling version of the novelist's Museum of Innocence project. This was installed at Somerset House, London, in 2016 and at the Museum of Cultural History, Oslo, in 2017. Calum Storrie's book *The Delirious Museum; A Journey from the Louvre to Las Vegas* was published in 2007.

McKenzie Wark is the author of *A Hacker Manifesto, Gamer Theory, The Beach Beneath the Street, Molecular Red*, and most recently *General Intellects*, among other things. Wark is chair of Culture and Media Studies at Eugene Lang College: The New School for Liberal Arts and of Liberal Studies at The New School for Social Research.

ACKNOWLEDGMENTS

Most institutions have more auspicious beginnings. Usually there is some sense of closure, even if fleeting, through some treaty or other historical document or moment that can be pointed to as a definitive end, a point from which something new can begin. We did not have that luxury. The argument that a "Museum of Capitalism" seemed to make needed to made public. As we started working through the practicalities of memorializing the era of capitalism, we became more and more involved, to the point where it became difficult to tell the difference between our role as curators and our part in the founding of an institution. And it became harder to discern the precise boundaries of the Museum and the "outside world." In this difficult process, we have been supported by a great number of people, some of whom made generous investments of time and resources, others of whom will remain as nameless, passing interlocutors in this ongoing conversation. For all of the support we have received, we are grateful and humbled.

The Emily Hall Tremaine Foundation deserves recognition for its bold support of challenging curatorial work. In particular, Heather Pontonio and Michelle Knapik have been phenomenal advocates. There were times when their belief in the project was the main thing sustaining ours.

This publication would not have been possible without the vision and tireless effort of Inventory Press and Project Projects, in particular, Adam Michaels and Shannon Harvey, our fabulous design team, especially Siiri Tännler. We're grateful for their willingness to take on such a challenging project and for pushing the publication further than we could have ever imagined. We are deeply appreciative of our editors Rose Linke and Eugenia Bell for their dedication to this project, and to all our contributors.

We celebrate the memory of Mark Fisher, whose writing about capitalism inspired many, and who passed away before he could complete the essay he was writing for this book. His presence is here nonetheless.

As we searched for a public location for the museum, several people working within the City of Oakland offered advice and advocated for the project, including Kelley Kahn and Roberto Bedoya. We found the most passionate and capable partner in Savlan Hauser of the Jack London Improvement District, who manages a difficult job with enthusiasm and grace. We're thankful for Savlan and her colleague Courtney Rosiek for taking on the challenge of supporting this project. We are proud to live and work in Oakland, California one of the most radical and forward-thinking cities in the US, and proud that Oakland is where our Museum of Capitalism first opened its doors.

A great number of scholars, economists, thinkers, and artists have advised the project along the way, offering both encouragement and critique which have advanced the project immensely over the past few years: Michael Albert, C. Greig Crysler, Sharon Daniel, T. J. Demos, Chip Lord, The Harrison Studio / Newton Harrison, David Dunn, Jennifer A. González, Geoffrey Hodgson, Jerry Mander, Rick and Megan Prelinger, Jennifer Dunlop Fletcher, and Allan DeSouza.

We're grateful for all those who invested the time, energy, and ideas to make our inaugural exhibition happen: Enar de Dios Rodríguez and Kelly Skye supported our highly complex exhibition project management; Jason Jay Stevens led exhibition design; Francois Hughes, James Morales, Packard Jennings, Evan Desmond Yee, and Dennis Palazzolo made the physical build of the exhibition happen; Charlie Macquarie, with the support of Ruth Copans, brought our Museum library to life; Bebe Basile and Greer Montgomery supported curatorial research; Elora Cuenco and Sabrina Habel helped with design; Emily Holm led educational programming at the Museum; Melinda James with Victor Hugo Duran produced video documentation; Sadie Harmon and Stagebridge designed performances within the space.

A number of archives and individuals supported our research, including The Labadie Collection at the University of Michigan and curator Julie Herrada; The Prelinger Library and its founders Rick and Megan Prelinger, and The Smithsonian Archive.

We appreciate the generosity of the numerous institutions who hosted guest lectures, workshops, discussion groups, and research as the project has developed,

including Trinity College, Dublin
Ireland; The Luminary, St. Louis,
MO; UCSC and its Digital
Arts & New Media MFA pro-
gram; The USF Museum Studies
Department and Design Program,
especially Professors Paula
Birnbaum and Liat Berdugo;
UC-Berkeley and the Townshend
Experimental Ethnographies
working group led by Annie
Danis and Annie Malcolm; Vierte
Welt (Berlin) and Aquarium
(Berlin). Thanks to our comrades
in the International Alliance
of Museums of Capitalism—
Museum des Kapitalismus
(Berlin, Germany) and the Musée
du C/Kapitalisme Museum
(Belgium)—who we had the
pleasure of convening with at the
first Global Summit of Museums
of Capitalism in 2017. Early
funders of the project included
the Left Tilt Foundation, the
Kenneth Rainin Foundation, the
Zellerbach Family Foundation,
and the Clorox Foundation's Mini
Arts Grant.

Others have provided support
in ways too specific or subtle
to describe here: Erin Elder,
James McAnally, Brea McAnally,
Sarrita Hunn, Alexander Klose,
Jonathan Ball, Janette Kim, Tiare
Ribeaux and B4bel4b Gallery, Dr.
Jeffrey Caren, Empire Logistics,
John Bacon, Mariah Cherem, Ben
Lotan, Tara Shi, Brittany Darrow,
Cristin McKnight Sethi, Sanjit
Sethi, Jenny Odell, Carrie Hott,
Audrey Davenport, Nina Elder,
Blake Fall Conroy, Misty Periard,
Rani Ban, Isabel Blue, Gabriel
Harp, Marcelo Viana Neto, Ashley
Hofferber, David Burke, Joshua
Carrafa, Bryan Ropar, David
Choberka, Sean Buran, Karin
Schrader, Jenny Gant Pham,
and Studio Bang-gu (Lucien Ng,
Daisy Dal Hae Lee, and Anthony
Zukofsky).

We thank our friends and
families, who have been patient
as we've repeatedly fallen silent
while working on an overwhelm-
ing project. We hope we have
done honor to the unwavering
support and respectful curiosity
shown to us by those who did
not live long enough to see the
Museum in person.

Finally, we offer our personal
gratitude to all of the artists
whose work is included in this
book and in other Museum
exhibitions and programs. Art is
fundamentally about seeing the
world for what it could be, and
their work has constantly shown
us more than we had imagined.

FURTHER READING

Albert, Michael. *Parecon: Life After Capitalism.* Verso, 2004.

Altvater, Elmar, Eileen C. Crist, Donna J. Haraway, Daniel Hartley, Christian Parenti, and Justin McBrien. *Anthropocene or Capitalocene?: Nature, History, and the Crisis of Capitalism* (KAIROS). Edited by Jason W. Moore. PM Press, 2016.

Angus, Ian. *Facing the Anthropocene: Fossil Capitalism and the Crisis of the Earth System.* Monthly Review Press, 2016.

Baptist, Edward E. *The Half Has Never Been Told: Slavery and the Making of American Capitalism.* Basic Books, 2014.

Bauman, Zygmunt. *Modernity and the Holocaust.* Cornell University Press, 2001.

Beckert, Sven. *Empire of Cotton: A Global History.* Vintage, 2015.

Bennett, Tony. *The Birth of the Museum: History, Theory, Politics* (Culture: Policy and Politics). Routledge, 1995.

Berger, M., Georgia O'Keeffe Museum Research Center, Baltimore County Center For Art University of Maryland, and Visual Culture. *Museums of Tomorrow: A Virtual Discussion.* Issues in Cultural Theory. Georgia O'Keeffe Museum Research Center, 2004.

Bonneuil, Christophe, and Jean-Baptiste Fressoz. *The Shock of the Anthropocene: The Earth, History and Us.* Verso, 2017.

Bottici, Chiara. *Imaginal Politics: Images Beyond Imagination and the Imaginary* (New Directions in Critical Theory). Columbia University Press, 2014.

Castoriadis, Cornelius. *The Imaginary Institution of Society* (MIT Press). Translated by Kathleen Blamey. MIT Press, 1998.

Fisher, Mark. *Capitalist Realism: Is There No Alternative?* Zero Books, 2009.

Frase, Peter. *Four Futures: Life After Capitalism* (Jacobin). Verso, 2016.

Fraser, Andrea. *Museum Highlights: The Writings of Andrea Fraser* (Writing Art). Edited by Alexander Alberro. MIT Press, 2007.

Gibson-Graham, J. K. *A Postcapitalist Politics.* University of Minnesota Press, 2006.

Gibson-Graham, J. K. *The End Of Capitalism (As We Knew It): A Feminist Critique of Political Economy.* University of Minnesota Press, 2006.

González, Jennifer A. *Subject to Display: Reframing Race in Contemporary Installation Art.* MIT Press, 2008.

Groys, Boris, Bazon Brock, Vito Acconci, Magdalena Jetelova, and Gerhard Merz. *The Discursive Museum.* Edited by Peter Noever and Hans-Ulrich Obrist. Hatje Cantz Publishers, 2002.

Harvey, David. *Seventeen Contradictions and the End of Capitalism.* Oxford University Press, 2015.

Harvie, Jen. Fair *Play: Art, Performance and Neoliberalism.* Palgrave Macmillan, 2013.

Hodgson, Geoffrey Martin. *Conceptualizing Capitalism: Institutions, Evolution, Future.* University of Chicago Press, 2015.

Kirshenblatt-Gimblett, Barbara, and Christine Mullen Kreamer. *Museum Frictions: Public Cultures/Global Transformations.* Duke University Press, 2006.

Kirshenblatt-Gimblett, Barbara. *Destination Culture: Tourism, Museums, and Heritage.* University of California Press, 1998.

Klein, Naomi. *This Changes Everything: Capitalism vs. The Climate.* Simon & Schuster, 2015.

Klose, Alexander. *The Container Principle.* MIT Press, 2015.

Kocka, Jürgen, and Marcel van der Linden, eds. *Capitalism: The Reemergence of a Historical Concept.* Bloomsbury Academic, 2016.

Lambert-Beatty, Carrie. "Make-Believe: Parafiction and Plausibility." *October* (2009): 51–84.

Leonard, Sarah, and Bhaskar Sunkara. *The Future We Want: Radical Ideas for the New Century.* Metropolitan Books, 2016.

Lilley, Sasha, David McNally, Eddie Yuen, James Davis, and Doug Henwood. *Catastrophism: The Apocalyptic Politics of Collapse and Rebirth* (Spectre). PM Press, 2012.

Lippard, Lucy R. *On the Beaten Track: Tourism, Art, and Place.* The New Press, 2000.

Lippard, Lucy R. *Undermining: A Wild Ride Through Land Use, Politics, and Art in the Changing West.* The New Press, 2014.

Malm, Andreas. *Fossil Capital: The Rise of Steam Power and the Roots of Global Warming.* Verso, 2016.

Mander, Jerry. *The Capitalism Papers: Fatal Flaws of an Obsolete System.* Counterpoint, 2013.

Moore, Jason W. *Capitalism in the Web of Life: Ecology and the Accumulation of Capital.* Verso, 2015.

Morton, Timothy. *Ecology without Nature: Rethinking Environmental Aesthetics.* Harvard University Press, 2009.

Mouffe, Chantal. *Agonistics: Thinking The World Politically.* Verso, 2013.

Perelman, Michael. *The Invention of Capitalism: Classical Political Economy and the Secret History of Primitive Accumulation.* Duke University Press, 2000.

Schweickart, David. *After Capitalism* (New Critical Theory). Rowman & Littlefield, 2011.

Stewart, Susan. *On Longing: Narratives of the Miniature, the Gigantic, the Souvenir, the Collection.* Duke University Press, 1992.

Storrie, Calum. *Delirious Museum : A Journey from the Louvre to Las Vegas.* I.B. Tauris, 2006.

Streeck, Wolfgang. *How Will Capitalism End?: Essays on a Failing System.* Verso, 2016.

Zhilyaev, Arseny, ed. *Avant-Garde Museology.* e-flux classics, 2015.

Zinn, Howard. *You Can't Be Neutral on a Moving Train: A Personal History of Our Times.* Beacon Press, 2002.

CREDITS

IMAGES

3, 5, 7, 9 Sketches by Elora L. Cuenco

18 Bottom, right: Used with permission. Smithsonian Institution Archives. Image OPA-1065.

19 Top, right: drawing by Allah El Henson.

28–41 Illustrations by Valeria Mogilevich.

50 Top, right: drawing by Allah El Henson.

51 Bottom, left: drawing by Elora L. Cuenco.

Middle, right: Courtesy Dan Budnik. Archival image used for mural concept by Chip Thomas, 2017.

60 Top, left and middle, right: drawing by Allah El Henson.

61 Top, right: Courtesy Dan Budnik. Archival image used for mural concept by Chip Thomas, 2017.

Bottom, left and right: drawings by Elora L. Cuenco.

71 Top, left: drawing by Allah El Henson.

Bottom, right: drawing by Elora L. Cuenco.

81–88 Courtesy the artists.

82–85 Photos by FICTILIS.

86–87 Part of the project News Today: A History of the Poor People's Campaign in Real Time, by Kate Haug.

89 © 2017 Center for Tactical Magic. Courtesy the artist.

90–94 Courtesy the artists.

95 © 2015 Curtis Talwst Santiago. Photo by Todd Duym.

96–98 Courtesy the artists.

100 © 2014 Curtis Talwst Santiago. Photo by Todd Duym.

101–103 Courtesy the artists.

104–105 Photos by Jeff Elstone. Courtesy the artist.

106 Photo by Kambui Olujimi. Courtesy of The New York Academy of Medicine Library.

107–108 Courtesy the artists.

109 © 2016 Evan Yee.

110–113 Courtesy the artists.

113 Photo by Justin Wonnacott.

114–127 Courtesy the artists.

128 Photo by Hsianglu Meng.

QUOTATIONS

17 Jameson, Fredric. "Future City," New Left Review 21 (May/June 2003): 73. 40.

18 Stein, Herbert. "Problems and Not-Problems of the American Economy," The Economist, American Enterprise Institute for Public Policy Research, June 1989.

19 Grosz, Elizabeth. *The Nick of Time: Politics, Evolution and the Untimely.* Crows Nest, N.S.W.: Allen & Unwin, 2005.

Burroughs, William S. *Break Through in Grey Room.* Sub Rosa, 2001.

49 Keynes, John Maynard. *Economic Consequences of the Peace.* 15th Edition. W W Norton, 2016.

50 Fisher, Mark. *Capitalist Realism: Is There No Alternative?* Winchester: Zero Books, 2009.

51 Benjamin, Walter. *The Arcades Project.* The Belknap Pr. of Harvard Univ. Pr., 2003.

59 Friedman, Milton. *Capitalism and Freedom.* University of Chicago Press, 2012.

60 Postman, Neil. "Museum as Dialogue." *Museum Provision and Professionalism* (ed. Kavanagh, G.). Routledge, 1994.

61 Bergson, Henri. *Matter and Memory.* Kent Solis Press, 2014.

69 Steyerl, Hito. "Is the Museum a Battlefield". Speech, 13th Istanbul Biennial, Istanbul, March 2013.

70 Barthes, Roland. *The Pleasure of the Text.* Translated by Richard Miller. Hill and Wang, 1975.
Debord, Guy. *Society of the Spectacle.* Black and Red, 1977.

71 Latour, Bruno. "Will Non-Humans Be Saved? An Argument in Ecotheology." *Journal of the Royal Anthropological Institute* 15: 459–75. Royal Anthropological Institute, 2009.

80 Galbraith, John Kenneth. *A Journey Through Economic Time.* Houghton Mifflin, 1994.

141 Leibniz, Gottfried Wilhelm von. *La Monadologie.* 1714.

142 Fisher, Mark. *Capitalist Realism: Is There No Alternative?* Winchester: Zero Books, 2009.

151 Williams, Raymond. *Resources of Hope: Culture, Democracy, Socialism.* Edited by Robin Gable. Verso, 1989.

156 Marazzi, Christian. *Capital and Affects: The Politics of the Language Economy.* MIT Press, August 4, 2011.

Museum of Capitalism
is published by
Inventory Press, LLC
167 Bowery, 3rd Floor
New York, NY 10002
inventorypress.com

Editors: FICTILIS (Andrea Steves and Timothy Furstnau),
Rose Linke, and Eugenia Bell

Production & Assistance—FICTILIS Studio:
Brooke Basile, Elora L. Cuenco, Greer Montgomery,
Enar de Dios Rodriguez, Kelly Skye

Design: Project Projects (Adam Michaels, Shannon Harvey,
and Siiri Tännler)

ISBN: 978-1-941753-15-6

Library of Congress Cataloging-in-Publication Data
available upon request

Authors: FICTILIS, Rose Linke, Stephen Squibb, J.K. Gibson
Graham, Ingrid Burrington, Steven Cottingham, Lester K.
Spence, Heather Davis, Kevin Killian, Jennifer González,
Chiara Bottici, Ian Alan Paul, Chantal Mouffe, Calum Storrie,
Susannah Sayler, Edward Morris, Lucy Lippard, T.J. Demos,
Sasha Lilley, McKenzie Wark, Sarrita Hunn, James McAnally,
Kim Stanley Robinson

Illustrations and Drawings: Elora Cuenco, Kyle Henderson,
Allah El Henson, Milo Ayden De Luca, Valeria Mogilevich,
Riiko Sakkinen, Calum Storrie

Printed and bound in Singapore by Pristone

Museum of Capitalism
www.museumofcapitalism.org

Produced on the occasion of the exhibition in Oakland, CA
from June 17–August 20, 2017.

This exhibition and book have been made possible by an
Emily Hall Tremaine Exhibition Award. The Exhibition Award
program was founded in 1998 to honor Emily Hall Tremaine.
It rewards innovation and experimentation among curators
by supporting thematic exhibitions that challenge audiences
and expand the boundaries of contemporary art.

 Tremaine Foundation